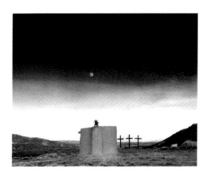

Four & Twenty Photographs

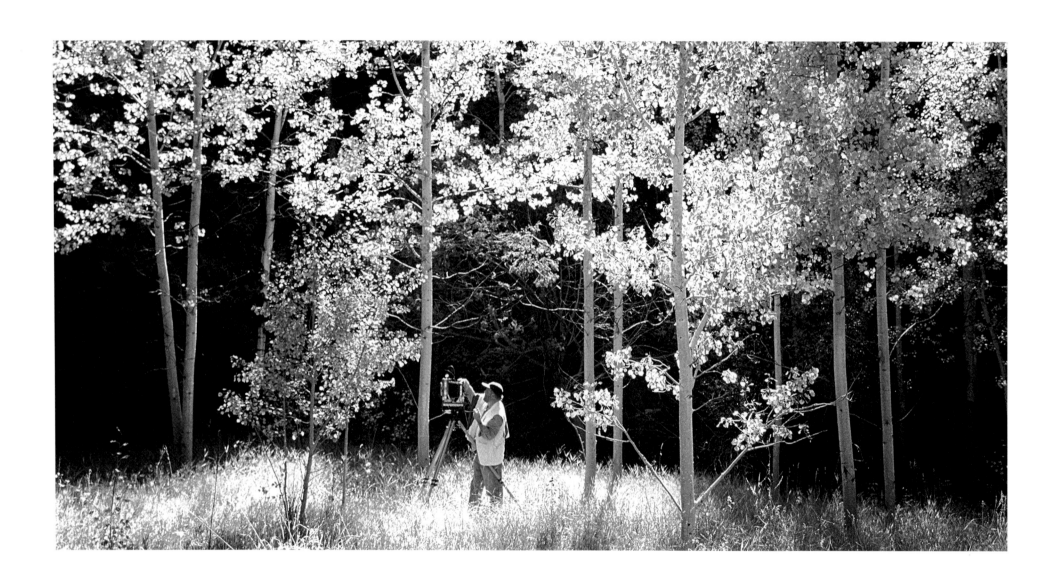

Four & Twenty Photographs

STORIES FROM BEHIND THE LENS

Craig Varjabedian

Robin Jones

AFTERWORD BY Jay Packer, M.D.

PHOTOGRAPHS BY

Craig Varjabedian

FRONTISPIECE: Craig Varjabedian Making

a Photograph, New Mexico 1998

by Cindy Lane.

LIBRARY OF CONGRESS CATALOGING-IN-PUBLICATION DATA

Varjabedian, Craig, 1957–

Four and twenty photographs :

stories from behind the lens /

Craig Varjabedian, Robin Jones ;

photographs by Craig Varjabedian ;

afterword by Jay Packer.

 p. cm.

Includes bibliographical references.

ISBN-13: 978-0-8263-4094-8 (pbk. : alk. paper)

1. Landscape photography—New Mexico.

2. Portrait photography—New Mexico.

3. New Mexico—Description and travel.

4. Photography—Technique.

I. Jones, Robin, 1958– II. Title. III. Title: 24 photographs.

TR660.5.V37 2007

779´.3609789—dc22

2006032151

To my friend Paul Cousins,
who came along for so much of the journey.

And to my daughter Rebekkah,
that these images and stories may be a window to her
father and thus illuminate her own journey.

CONTENTS

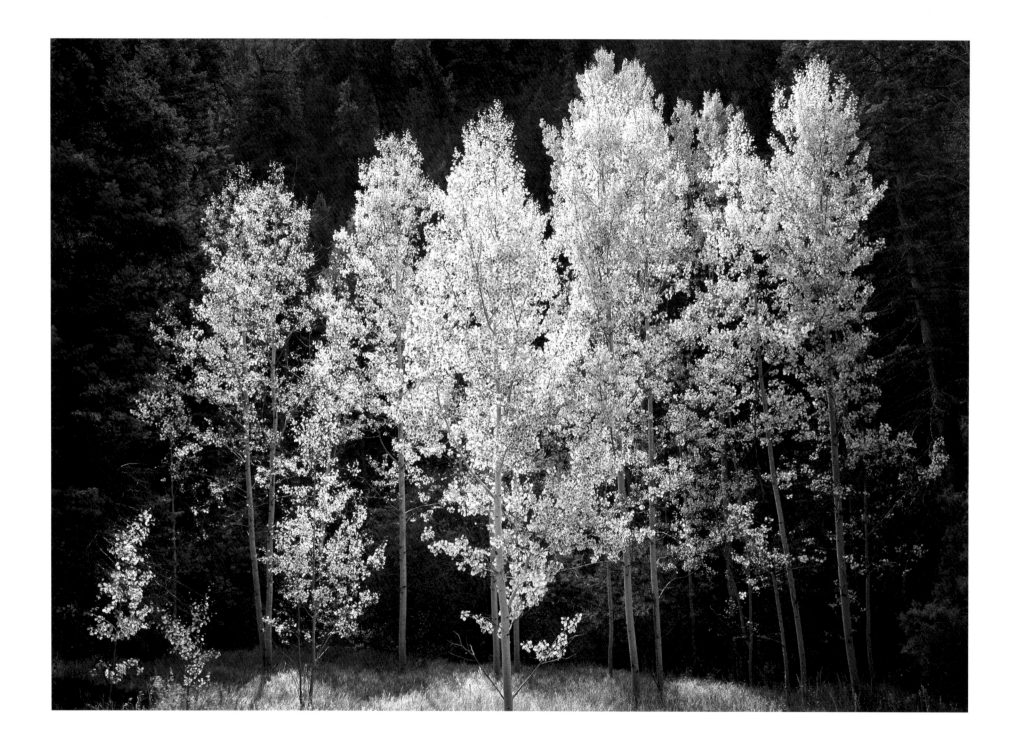

PREFACE: The Making of
Four & Twenty Photographs: Stories from Behind the Lens

ROBIN JONES

CRAIG VARJABEDIAN AND I MET SOMETIME IN 2003, when our daughters were in school together. Waiting to pick them up, we'd talk about education, art, family, books, movies, you name it. We found we shared a similar sensibility toward art, nature, and description. Eventually I began writing for him and the New Mexico Photography Field School, of which he is director.

Because I love storytelling and Craig lives to make photographs, we decided to turn these two passions into a book. The book would cover a broad period of Craig's work. We narrowed down the huge number of possible photographs to twenty-four; it just felt like a good number. When we announced this, my husband Charles chimed in "Ah, Four & Twenty" from the old nursery rhyme. That's how the book found its name.

When Craig and I need to discuss ideas or clarify story points, we meet in the most ideal conference place in Santa Fe—Tia Sofia's restaurant on San Francisco Street. The owners have known Craig for years, so going in with him is like being with a celebrity. We sit in a booth, drinking Arnold Palmers (ice tea with lemonade), waiting for our enchiladas, and talking. And talking.

One day, he was telling me about making the photograph *Sunset and Evening Storm* (page 3). He got distracted into describing the "widowmaker," an exceptionally heavy tripod he was using at the time. Which led to the story of how he met the physician Jay Packer, who wrote the afterword for this book (who now owns the "widowmaker"), which sidelined us to Craig's dog, Allie, which had just had surgery. Craig had called Jay to get some medical condition explained. When we finally got back to the actual photograph, our plates were clean, sopaipillas with honey had been devoured, and the lunch crowd had long since gone.

Craig loves to tell stories about photographs and photography. What he'd prefer to keep away from is technical talk. He can be as "nuts and bolts" as necessary, but to him photography is something of the heart more than of the head. His favorite quotation, from Saint-Exupéry's *The Little Prince*, says it all: "It is only with the heart that one can see rightly; what is essential is invisible to the eye."

He prefers to discuss photography from a more subjective aspect. Mention a beautiful place, a wonderful sensation,

or your emotional response to a sunset, and you'll get his take on similar things. His photographs and his photographic process are often private and personal matters to him, or ones difficult to explain in words.

And that was the impetus behind this book—trying to put into words what Craig Varjabedian does, what he cares about, and why he photographs. That as well as his desire to share, to pass on what he has seen and done. The photographs reproduced here serve, in a way, as mile markers on his artistic journey—a journey he invites readers to take with him. He tried to explain what he hopes readers will gain:

Shortly after I moved to New Mexico, I took my camera up to the mountains above Santa Fe to photograph the aspens. I had the dark cloth over my head and was working away composing an image when I felt a gentle tug on the cloth. I figured it might be the wind and ignored it. But then, after a moment, I felt another tug. Maybe someone had come up and found me and wanted my attention. I very slowly turned around and peeked out from under the cloth. A foot away from me stood a fawn, its eyes huge and its tail flicking excitedly from side to side. It was staring at me with rapt curiosity—I stared back with awed joy. Time seemed frozen. Then, out of the trees, the mother appeared, standing about fifteen feet away, and anxiously flicked her tail back and forth. The fawn dipped its head at me and leaped away to join its mother. In seconds they were gone. The feeling of that experience, that magical, pristine moment, is what I hope I can convey in my photographs.

The stories that accompany the photographs offer voices from farms, ranches, fields, forests, museums, books, and more. They deal with the photograph itself, the experience of making it, or the image or person or place in the photograph. Photographs tell their own stories, certainly, but in this collection we try to present more, a relationship between image and imagination. Sometimes the photographs are enriched by being viewed from another angle—from the perspective of the past, say, or the perspective of an observer. Sometimes they are made more meaningful by the accompaniment of stories in voices other than the photographer's.

The process of getting the stories out of Craig and onto paper was an adventure in itself, time consuming and rewarding. Craig had already put some of the information down in his journals. Some of the stories came up as we sat at his dining-room table and I recorded him talking about a particular photograph or about photography in general. Sometimes I took notes while he spoke, driving down the highway, sitting at a restaurant, hiking through a canyon. Everything was potential material; every place and time could result in a new story or a recollected memory.

Sometimes I went out in the field with Craig. On January 25, 2004, I wrote in my journal:

Today I've been up to Floyd Trujillo's house to meet with him and Craig and, I hope, to go beyond locked gates on Ghost Ranch to see more of the ranch. The weather is blue yet cloudy and the drive is uneventful, except for the scenery, which is beautiful and stark—what we call normal out here for the West, appreciated by those who prefer this kind of landscape.

On the road to Floyd's, I drive past the river. There is a small turnout that goes down to the bank, a white, sandy-looking area, and I think how pleasant it would be to drive down there, set up camp, and work or, better yet, sit and watch the clouds go by. As I drive past, I see up ahead Craig's truck, perched on the side of the road. His camera is set up on the tripod, and he's leaning against the truck, just watching the sky.

I pull up, nose to nose, and get out and join him. He's been out taking pictures around the village since 7:00 this morning (it's now 10:45). "I was going to go out further, but I saw the mountain and

the clouds and thought, why not?" He's exposed six to seven film holders so far of El Cerrito, the mesa opposite, with the light drifting over it. The clouds have been easing by as well, except for one formation that has stayed, more or less, right over the mountain. We discuss its shape for a bit and decide it's a "ham" cloud—one that likes to be photographed.

A car approaches, and Craig, muttering and sighing under his breath as the car slows down, has spied a moment through the lens that he likes. But the car's slow careful progress kicks up dirt and a breeze. Craig waits, trying mentally to get the driver to go faster, but no, he inches by, courteously waving with Craig glaring at the ground as his moment slips by. Too late. The moment has passed. Craig decides it's time to pack it in, since I have arrived, and he starts to dismantle his equipment—but glancing at the mountain sees the light approaching again for another good photograph. He races to the truck to get out the holders he had just put away, gets one, hurries back to the camera to insert it, but again, too late—the light is now "gone." So he sighs and blames it all on me, grinning, and we drive off to Floyd's.

When I wasn't listening to or recording Craig, I researched information on my own and interviewed other people involved with a particular photograph. When I had enough information, I put it together in rough story form. Then the editing began. Craig and Cindy Lane, Craig's photographic assistant and business partner, would read the draft, and one of them might remember, "Oh wait, that detail isn't quite accurate," or "Wasn't that also the time we met so-and-so?" I'd gather new information, correct errors, and come back. Each time, revisions, corrections, additions. Each time, the story would be fuller, richer, more meaningful.

Cindy Lane is an important part of this book. She has been Craig's assistant, critic, helper, and friend for years. Craig shares that Cindy is

For most of that morning, the swirling clouds completely obscured El Cerrito. About the time Robin met up with me along the road the clouds finally lifted and I was able to make this image.

(*El Cerrito, Late Winter Storm, Abiquiu, New Mexico, 2005.*)

a fellow Canadian, excellent cook, organizer supreme, and all around one of the most generous-hearted people I've ever met. Cindy came down from Canada to Boulder, Colorado, where she lived for a while. She moved to Santa Fe in 1988. I met her when she was working at a local copy shop. I had taken in a photography workshop flyer to photocopy, and she helped me. She said, "Oh, that looks like a fun class," and she showed up on the first day. We hit it right off. We kept in touch, and whenever I needed some extra help in the darkroom or with studio tasks, I'd turn to her. Soon she went from off-and-on help to part-time assistant to full-time assistant, and nowadays she's my business partner.

We've traveled around the country, on photographic journeys and teaching workshops. She's become a wonderful photographer herself—she took the photograph of me in the aspens (frontispiece). I could say a lot about her in terms of her personality—her humor, her sensitivity, her insight. I could say a lot about how she has organized, developed, and streamlined my professional career, how she has freed me up to do what I love best—photograph—while she takes care of the other details. Or I could say simply, it's not everyone who is lucky enough to have a best friend as a business partner, and that I have been lucky and blessed to work with Cindy.

Between Craig and Cindy, I gathered stories, insights, and lessons. Especially important was the photographic information, an issue that particularly needed accuracy and simplicity. If I, an innocent whose only experience was with a point-and-shoot camera, could understand and communicate Craig's discussions of film, exposure, and development, then a general audience would probably be satisfied, too. Craig, of course, was never satisfied, never finished trying to explain and describe. Fortunately, he would step back and realize—"This isn't a textbook, it's

a book of stories"—but I'm sure there is much more he'll want to say in future books.

If I had to outline Craig Varjabedian's photographic philosophy, as inferred from the stories I have heard and written, I would highlight five elements that readers will recognize in story after story. First, he believes that an understanding of technique and a practiced ease with equipment is necessary so that the photographer can turn his or her attention to inspiration and the moment of photographing. Second, a photographer needs to cultivate the ability to shut off all mental distractions and dialogue in order to focus only on the moment at hand. Third, he or she needs to develop an appreciation for and the ability to recognize the "decisive moment," the moment when everything—light, perception, environment—falls into place. Fourth is the importance of waiting for the subject to reveal itself in its authenticity rather than trying to force an image or event into the frame of the camera lens. And fifth, a photographer must come to understand that an inspired photograph is a gift for which to be thankful.

Although there are certainly more lessons Craig would want to share—additional insights from over thirty years of photography—the point of this collection is to share these stories, to explore both the making of the photographs and their meanings within a larger context, and, it is hoped, to enable readers to enjoy the world of Craig Varjabedian's photographic experiences so far.

ACKNOWLEDGMENTS

THE JOURNEY FROM NORM STEWART'S HIGH SCHOOL PHOTOGRAPHY class at Lahser High School in the mid 1970s to the creation of this book has been an incredible adventure. I humbly recognize that my life and photographic career have been shaped by amazing visitations through the lens of my camera and by people who have helped and changed my life. It is serendipitous that, as I began writing this, I received a surprise telephone call from Mr. Stewart announcing his retirement from teaching. And it is appropriate that, as I look back over the last thirty-five years, these acknowledgments begin where my career also began. So thank you, Mr. Stewart, for helping set the bar so high; you set the standard for excellence that I have always tried to achieve in my work.

A chance meeting with Ansel Adams at a photography gallery when I was about fourteen deserves special note. I remember as if it were yesterday the powerful clarity I experienced while seeing his beautiful photographs of Yosemite and the Southwest and being able to talk to him about them. My life's purpose truly began with this moment of realization.

It was fortuitous that while in high school we used Phil Davis's textbook *Photography* as the basis for our photographic study. I am grateful that after high school I had the opportunity to study with Professor Davis and with Professor David Reider at the University of Michigan, where

I learned much about the craft of photography and began to acquire a sense of which direction to best point the camera.

Also at the University of Michigan I had the good fortune of studying and becoming friends with renowned gestalt psychologist Dr. Rudolf Arnheim, who patiently provided much needed criticism and support of my early photographic efforts. As I write these appreciations, I delight that Dr. Arnheim is 102 years young.

At the Rochester Institute of Technology, Professor Dr. Mihai Nadin, an outspoken man who came to the institute as a visiting professor, befriended me. I am grateful that at a time of real confusion in my photographic work, you provided much needed support, clarity, and direction to my path.

I owe much to photographer Paul Caponigro, who taught me the importance of freedom, discovery, and listening in the nurturing of thoughtful images. I am grateful for your photographs and all they have taught me. I am also thankful for the time spent working for you when, around your ever-present coffee pot, you would share lessons on craft and the commitment that fine photography requires.

To Cindy Lane, first my student, later my friend, and now my assistant extraordinaire and business partner, I delight in the fact you have been along for much of the journey and am grateful that you were there to hand me a lens, a film holder, or a gentle smile when I most needed them.

Deep appreciation goes to my good friend the Reverend Paul Cousins, who also joined me for much of this journey. I don't get many opportunities to call you Reverend so with my deepest respect and admiration, please allow me to do so here. When we met years ago, I was teaching a photography workshop you attended and gratefully along the way I became *your* student. I'll never be able to repay you and your wife Doris for the extraordinary patience and kindness you have both shown.

They say that behind every man is a great woman and my life is no exception. I remember the first day I met Kathy at the cooperative housing we shared at the University of Michigan. She was painting the walls of her room, and seeing her illuminated in the afternoon light streaming through the window simply took my breath away. After twenty-eight years together, her love and patience with me and my work remain an incredible gift. Our amazing child Rebekkah is the "glintses" in our eyes!

My parents Suren and Hazel Varjabedian deserve more than just a kind word. It was my father who shared with me as a child an early appreciation for nature on many long hikes at Point Pelee National Park in Ontario, Canada, and who later took me as a teen to the wilds of Alaska for a once-in-a-lifetime adventure on the then unpaved Alcan highway. It was my mother who taught me an appreciation of simple and beautiful things through the many handcrafted items she made that adorned our home when I was growing up. Words will never express my love and appreciation for all that you have done.

My thanks also goes out to my wife's parents Richard and Ruth Strickland for their overwhelming generosity, particularly during our "thin" years, and for giving me their greatest gift, their daughter Kathy.

Throughout the West, many "angels" have come to my aid while traveling and making photographs and I thank them for going out of their way to help a weary photographer while on the road. In particular, I'd like to mention Floyd and Virginia Trujillo, who on more than one occasion have provided me with wise counsel, a place to rest, and a delicious meal while exploring the Rio Chama Valley. I am honored that they consider me a member of their family. Ken Young, a fine Navajo photographer, has been incredibly helpful while exploring the Antelope Slot Canyons, areas around Page, Arizona, and Monument Valley.

The Penitente Brotherhood has been a huge source of inspiration for me personally and in my photographic work. Their life's dedication to the passion of Jesus Christ serves as an incredible example of all that people might become and all that people should strive to be. I am particularly grateful to Charlie Carrillo, Florencio Gonzales, Felipe Ortega, and Floyd

Trujillo for the faith and trust you have shown in me and my work to sensitively portray the moradas of the Penitente Brotherhood. I know you took a lot of heat for helping this outsider understand something so close to the heart of Catholic Hispanic New Mexico as the Brotherhood. My life has been made better and richer by knowing you.

Other people I have met along the way that made the journey a little easier and more enjoyable include Barbara Brenner, Taos Historic Museums board member; printer Brian Brigham; Myra Bullington; Kurt Cousins, Kali's caregiver; Dr. Mark Cox; Rob Craig, executive director of Ghost Ranch Conference Center; the late filmmaker and photographer Karl Kernberger; Michael Kamins, executive producer at KNME-TV5; Liz Lockhart of the Jackson Hereford Ranch; independent researcher Margil Lyons; the late Leopoldo and Martín Martinez; Nolia Martinez, caterer extraordinaire; Victor Martinez and his Cadillac *Chimayo*; Dorothy Massey of Collected Works Bookstore; Henry and Peggy McKinley; the late photographic historian Beaumont Newhall; Marina Ochoa, director of the Archives and Museum of the Archdiocese of Santa Fe; santeros Eulogio and Zoraida Ortega; Malcolm Rogers; photographer LeRoy N. Sanchez, Public Affairs Office, Los Alamos National Laboratory; New Mexico's historian laureate Marc Simmons; writer and historian Fr. Thomas J. Steele, S.J.; printer Victor Scherzinger; cowboy and actor Stoney Wellman; Cathy Wright, director of the Albuquerque Museum; and Karen Young, former director of the Taos Historic Museums.

I am always humbled (and slightly blown away) when someone purchases a photograph of mine. In some real way the photographic prints I make become like my own children. They have been nurtured and groomed and have hopefully been taught to behave themselves when they leave my studio. I am pleased when they find good homes. I am grateful to the many collectors who have purchased my work over the years and to the galleries that represent my work: the Gerald Peters Gallery in Santa Fe; the Afterimage Gallery in Dallas; and Cheryl Pelavin Fine Arts in New York City.

Financial support for my photographic projects seems to appear remarkably at just the crucial moment. I wish to thank the following friends and organizations for their financial support of my photographic efforts: Howard and Ellen Lowery; the National Endowment for the Arts; the McCune Charitable Foundation; the Samuel H. Kress Foundation; Charles Strong and Mag Dimond at the Peter and Madeleine Martin Foundation for the Creative Arts; Craig Newbill at the New Mexico Endowment for the Humanities; New Mexico Arts—Department of Cultural Affairs; and Los Alamos National Bank/Trinity Capital Corporation, particularly Fidel Gutierrez, Pam Mayfield, Joann Sterrett, Anne Wilson, and Denise Terrazaz.

If Reverend Henry Ward Beecher is correct that "a tool is but the extension of a man's hand," then I am grateful for the Ebony camera I use and the esteemed Mr. Hiromi Sakanashi for its design and fine craftsmanship. My 5 × 7 view camera never lets me down even in the most difficult shooting situations and is an absolute joy to use—"she" has become a good friend. I am indebted to Ian Wilson, Ebony's North American representative, for his ongoing assistance and support. I would also like to thank Bogen Imaging, Lowepro USA, and Canon USA (suppliers of equipment I use) for their commitment to making the finest photographic gear and their continued support of our workshops at the New Mexico Photography Field School.

When digital photography really began making its mark on the photographic landscape in the 1990s, I dreaded the big changes that were underway. I am grateful to William Plunkett, who embraced digital photography for his own fine photographic portraits of wildlife, for helping me see the amazing possibilities of this new medium. I also wish to thank Michael Sherwood for facilitating my digital journey with Adobe Photoshop and the Apple Macintosh computer, tools necessary to bring digital images to life.

At the University of New Mexico Press, I am thankful almost beyond

words for Luther Wilson's faith, generosity, judgment, and friendship. He is what every artist and writer dreams for in a publisher. Also at the Press, I wish to thank Melissa Tandysh for her beautiful design of this book that provides such a wonderful stage for the photographs to speak with their own voice. Maya Allen-Gallegos, managing editor, and Glenda Madden, sales and marketing manager, deserve additional thanks.

I wish to thank Michael Roswell of Roswell Bookbinding in Phoenix for bringing his creative skills and meticulous attention to detail and crafts-manship to a limited edition of *Four & Twenty Photographs*. This handsome limited edition includes an original photographic print and a hand-bound, slip-cased book available from the photographer's studio.

My deep appreciation goes out to the Most Reverend Michael J. Sheehan, Archbishop of Santa Fe, Archie West and his sidekick Buddy, Sadie Lombardi and her dog Buck, Sparrow and her cowboy Richard Stump, Kali the Wonder Dog Cousins, Pete the Zebra donkey, and Anthony Parker for allowing me to photograph you and for sharing your stories. I delight that we were able to make these photographs together and share them and your stories in this volume.

My thanks to poet Victor Hernandez Cruz for use of his poem "Lowriders." After many years of pausing to watch lowriders cruising the streets of Española, I delight in your vision that lowriders are "butterflies with transmissions."

I am convinced that behind every author is a good editor and this book was fortunate to have three. Jane Kepp, Dr. Mark Bradley, and Dr. Jane Poths provided valuable editorial contributions to the text of this book. Their skillful editing as well as their concern for detail and con-tinuity are greatly appreciated.

In arranging an exhibition tour of these photographs, I would like to especially thank the following individuals and institutions: Thomas W. Jones, executive director, and Cristi Branum, adjunct curator of exhibits at the Museum of the Southwest, Midland, Texas; Ben Breard, director of the Afterimage Gallery, Dallas; Catherine Whitney, director of Twentieth Century American Art and Photography at the Gerald Peters Gallery, Santa Fe; and Cheryl Pelavin, director of Cheryl Pelavin Fine Arts, New York.

My sincere gratitude goes to Jay Packer; your afterword eloquently elaborates on my approach to image making. I delight that we have had so many wonderful opportunities to make photographs together and to plumb the ether of the night for the deeper possibilities and mean-ings of our work with the lens. Supportive of my photographic efforts even before we first shook hands, your encouragement, wise counsel and friendship are invaluable.

Robin Jones, my collaborator on this book, joins me in warmly thank-ing the many people already mentioned and would like to offer her par-ticular gratitude to those individuals who have offered suggestions, infor-mation, advice, and have generally helped in the writing of this book: Peggy Barroll, Davíd Carrasco, Dawn Foy, Bernie Foy, Elizabeth Hanley, Robert Jones, Nancy Jones, Susan Jones, Donna Packer, Helyn Strickland, and Aba Weberjones.

Many thanks to all the students I have had the pleasure of working with over the last twenty-one years at the New Mexico Photography Field School. I am truly grateful to you for bringing your personal best to the workshops and for all that you have taught me as we have explored the beautiful light of New Mexico.

And finally, my sincere thanks to Robin Jones for patiently listening to these stories and eloquently rendering them in this book. I so deeply admire your ability with words and delight in your joyous spirit. Thank you also to Charles Weber, Robin's husband, for divining *Four & Twenty Photographs*, an inspired title for the twenty-four photographs and stories presented in this book.

Craig Varjabedian
Santa Fe, New Mexico

Four & Twenty Photographs

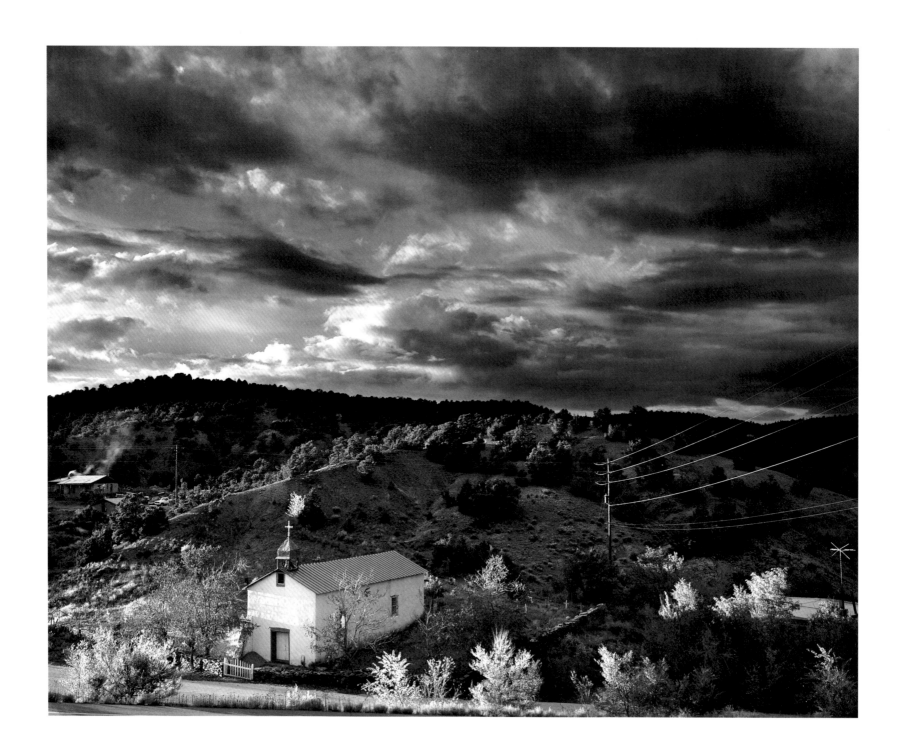

SUNSET AND EVENING STORM
CAÑONCITO AT APACHE CANYON, NEW MEXICO, 1985

ROBIN JONES

THE VILLAGE OF CAÑONCITO AT APACHE CANYON (cañoncito means little canyon), with its small adobe houses and wood and tin buildings, sits along County Road 55A, encircled by mountains and greenery. Cañoncito is a small community that supports itself not on tourism but on hard, steady work. Church on Sunday is a time of heartfelt prayer and worship.

Many villages in New Mexico, and in the Southwest in general, have faced changes offering new technology, a different kind of life, and a moment of choice in which culture or religion may take second place to growth and development. Such changes need be neither intrinsically good nor bad; only the people living in those places at those times can make that judgment call. But we all see the changes coming, like a storm approaching over the mountains.

Storms can bring nourishment, and they can bring destruction. In New Mexico storms bring much-needed rain. They bring the beauty and grandeur of lightning and thunder. But too much rain or fire caused by lighting can endanger a community.

This photograph focuses on an approaching storm. Parts of the ridge and the small church—la Capilla de Nuestra Señora de la Luz (the Chapel of Our Lady of Light)—gleam in the waning sun. The church has become a natural part of its surroundings. However, utility power lines, telephone poles, a television antenna, a Chevy truck, and a nearby house symbolize changes that might already have distracted the community from its faith, from a sense of grace. The clouds and tones of light and dark foretell that other changes may yet come.

But a sense of abiding faith and continuity also resides in this photograph, conveyed by a potent symbol. Above the church steeple, a bush is highlighted, lit like a flame by the sun. It recalls the burning bush in the biblical tale of Moses, promising succor and redemption. What do the other objects in the photograph promise—the telephones, the television, the truck? It is up to the viewer of this image to make a choice, to abide by a decision, about how to understand this light and this message.

This photograph poses possibility and promise, a sense of continuity coupled with change, a juxtaposing of light and dark, hope and fear. The photographer happened to be

"at the right place at the right moment" to catch the smoke curling from the nearby cabin chimney, mirroring the swirling clouds, and to note the way the illuminated power lines redirect vision back to the little chapel. He made an image in which the afternoon light glorifies the church steeple, the church window, and the bush above the church. But what is more, he saw a moment that transcended photography or image: a moment of rapture—a window into heaven.

CRAIG VARJABEDIAN

Making a good photograph is more than recognizing something beautiful. When I'm in the darkroom, I'm trying to create a print that reflects an experience and share it with the viewer. The whole process intertwines technology, intuition, and luck. I doubt that I could ever fully articulate what I go through to make an expressive print. When I first started photographing and working in the darkroom, I realized that I was working "by the numbers." More than thirty years of practice and experimentation have made the process more fluid and instinctive. I understand now that the fewer "steps" I have to go through, the less gear I carry around, and the fewer numbers I keep in my head, the better pictures I make. I don't want to be tripping over materials and techniques.

The one thing that never changes is that moment of recognition when I feel the play of light, shadow, and texture resolve itself into something wonderful.

I was driving in my truck one November afternoon, simply following the light, waiting to see where it would lead me. I could see some clouds building in the eastern sky. I'd been driving for a couple of hours when I finally came to this little chapel at Apache Canyon—the Capilla de Nuestra Señora de la Luz. I pulled off at the next exit and doubled back to the village of Cañoncito. I was struck by how beautiful it was: the sky, the hills, and the church formed a moving tableau. Everything seemed so simple, so honest. I had driven past the church before and admired it. But that day I could see images. The landscape in which the church sat, the clouds on the distant horizon, the light raking across the hills—all were part of a much bigger picture.

I knew that in order to create an image of those relationships, I'd have to set up my camera as high as possible. The only good place was an embankment on the northbound side of the highway. It was a steep and unsure climb. I was carrying a metal case with all my camera gear and my heavy wooden tripod (my friend Paul Cousins calls it the "widowmaker"). After losing my footing several times, I finally made it to the top.

Sometimes I think my best photographs are made when there's only one place to set the camera, one distinct view that calls me. Ten feet over would be wrong; another hill would be wrong; a lower perspective wouldn't work. That's the message of simplicity—there shouldn't be a lot of fussing; the image should fall right where it needs to on the ground glass. For this photograph, I had found the perfect spot for my camera.

Now I was high enough to view all the parts of the scene and to begin to understand how they related to each other. I decided I didn't want to include too much of the highway that runs right at the foot of the church, but I wanted to show the little trees that are at the bottom of the frame. Those decisions established some guidelines for me. Then I noticed the power lines to the right of the church and how intrusive they seemed. But studying them, I realized they directed my vision back to the church. They were an important part of the environment, and removing them would somehow take away from the meaning of the photograph. Even if my photographs sometimes look as if they come from out of the past, they reflect the time we live in. The power lines, the television antenna, the white Chevy truck—all these things are parts of our lives. They provide an authenticity to the scene.

I set up my camera. I metered the scene. I wanted to make sure I exposed the film sufficiently to render the shadows with enough detail, not

allowing them to merge into blackness. If I exposed the film incorrectly, it would be difficult to fix.

On the top of the hill, I could see clouds nearby. The sun was beginning to set on the horizon. I waited. The clouds moved in, a dark canopy encircling the scene. The sky broke open, and the clouds framed the last light of day falling on the chapel and the trees.

I made my picture.

The sky cleared. The clouds moved away. In seconds the sun went down into the valley. I came away with six exposures that I was eager to develop.

I have certain criteria when it comes to developing my film. I first look at the resulting negatives on a light table to see which ones will produce good prints. When I examine a negative, I'm looking to make sure the aspects of the scene are rendered properly, the shadows have detail, and the highlights are not blocked. A good print will have a sense of texture and form if I've exposed and developed the negative properly. I want to be certain I have a negative that will allow me to make a print that shares what it was like to be a witness to a given moment.

In the darkroom this time, I wanted to preserve the sense of the light from that day. After developing the negatives, I laid them out on the light table. Back then, I had a little twenty-four-inch-square homemade light table. I couldn't put all the negatives out to look at them together. I didn't make proof prints of every negative in those days. By sheer luck, I ended up printing the best one. Several years later I decided to go back and proof everything. From the way the clouds were moving across the landscape, I could tell roughly which one was the first exposure, the second, the third. In only one exposure did the bush above the church appear to be burning and the sunlight glow through the window of the church. In all the other negatives, those two elements were missing.

This image has to do with the details—the rising smoke, the wire touched by light, the gray gravestones, the light that illuminates the chapel door and the cross. The detail is so meaningful, so delightful. Everything happening at that single moment gives it life. This is not a still life of a church—there's someone minding the fire in the house next door, and someone may be using the phone somewhere else. There is a human presence here.

ROBIN JONES

The photographer stands amid his work, smiling, nodding, chatting to friends and guests. His eye is caught by a stranger coming into the gallery. An older woman, an *abuelita*, or grandmother, she walks around, stopping to look at each photograph carefully, each time tapping her gnarled finger on the glass. As the evening progresses, he watches her move around the room several times, looking at each picture with care. Finally she walks over to him and taps him on the shoulder. "Please, will you come with me, to look at something in one of your pictures?" "Of course, ma'am," he says, and follows, winding around small groups of people.

At the Cañoncito image, she stops. He looks at his own work: the small, plain church, the clouds rolling above. He had come across this church during the first weeks he had lived in Santa Fe. He had visited the site often, until the scene began to unfold in front of his lens. The woman taps the glass, first at the cross on top of the church and then at the bush, glowing in the remnants of sunlight. She looks at him and asks, "Do you know what you have made a picture of? Do you know the story of this?" The photographer starts a polite reply: "I suppose it was the church steeple against the dark clouds that I—" He hesitates and stops. She speaks: "You have taken a picture of something more, you know. Here, you have captured the face of God. You have seen the face of God in the same way Moses met him on a mountaintop: the burning bush on the hillside." She taps the glass once more, looks shrewdly into his eyes, and smiles: a blessing of recognition and love.

IN PURSUIT OF THE DIVINE LIGHT:
The Moradas of the Penitente Brotherhood

CRAIG VARJABEDIAN

Throughout all of New Mexico . . . in small Hispanic villages . . . there stand sentinels of our ancient and living faith in the form of the dwelling places, the *moradas,* those buildings that resemble a simple home. Each one of them is the place where God has pitched his tent to dwell among us. For the faith of my people teaches us that dwelling places that God has prepared for us in His Celestial Kingdom are mirrored in this earthly existence in these most sacred of structures. These are not the cathedrals of Europe, nor the massive Mexican temples of the ancient ones, just simple unadorned dwellings that reflect some of the Native American religious mentality which has created the Pueblo kivas. The moradas seem unable to convey, in and of themselves, the magnificence of heaven. But when you are inside you can sense the joy and peace of heaven that surpasses all earthly beauty. Mystically, the morada is transformed into the most beautiful of buildings on this earth, though no words will ever convey this.

—Hermano Felipe Ortega,

from the foreword to *En Divina Luz*

SOMETIME IN THE LATE EIGHTEENTH OR EARLY nineteenth century, an organization of lay Catholic villagers emerged in New Mexico to fill the religious and spiritual needs of the Hispanic people. This organization, commonly referred to as the Penitente Brotherhood, built private sanctuaries of worship known as moradas, from the Spanish word *morar*, meaning "to dwell." The morada serves the *Hermandad* (Brotherhood) as a ritual sanctuary and meeting place throughout the year. Besides conducting pious observances focused on the spirit of penance and the passion of Jesus Christ, the Brotherhood renders mutual aid and helps its communities. This adherence to unqualified Christian charity has substantially contributed to village survival in the long-isolated region.

Penitente moradas are more closely related to domestic than to church architecture. These unassuming one-story buildings were often built in hard-to-reach places from materials readily at hand: adobe, stone, and timber. Many of the moradas that survive today were built in the 1800s, although new ones continue to be constructed.

Moradas are indigenous organic forms that rise quietly from the land. They stand as visual reminders of the past but speak more eloquently about the present. Today's economic and social realities can make it difficult for community members to provide the physical care that moradas require. The Brothers and their communities faithfully maintain and use many of them, but some are in disrepair and have even been targets of vandalism.

One of the richest experiences in my life was photographing the Penitente moradas of northern New Mexico and southern Colorado. The project is recounted in full in the book *En Divina Luz: The Penitente Moradas of New Mexico*. I made photographs at more than two hundred morada sites, producing well over a thousand images. The entire collection is now housed at Southern Methodist University in Dallas, Texas.

The project took nearly eight years, from 1989 to 1996. Two of my biggest concerns were logistics and cultural sensitivity. I had first to research and begin to locate the moradas. Neither the Catholic Church nor the Brotherhood knew where they all were. I learned of them by hearsay, by word of mouth, and by research. I was fortunate to be able to rely on the valuable work of Tom and Margil Lyons, who had spent many years traveling and photographing moradas. Tom died shortly before I started this project, so I never got to meet him, but Margil generously gave me access to their maps, snapshots, notes, and stories, and we began a warm friendship.

As an outsider to the Brotherhood, I was cautious about approaching people and places. As I came closer to understanding the moradas as buildings (where they were, who was involved with them), I also became aware of their importance, not only to the *Hermanos* (Brothers) and the communities they served but also within a much larger picture. I came to feel that the moradas and the Brotherhood lay at the core of Catholic Hispanic New Mexico. Many people believe that the strength of Catholic faith in New Mexico today rests on the Brotherhood's efforts. Throughout the centuries, isolated by distance and time from Catholic priests, villagers

needed someone to say last rites, baptize children, and maintain a moral direction in their communities. The Brotherhood fulfilled many of these needs.

Understanding this larger context enabled me to reach out to individuals and communities with greater sensitivity. These were not simply buildings but tangible symbols of a way of life. Consequently, my photographic decisions were better informed.

I knew my photographs would not be of the interiors of moradas—these were the sites of private devotions, and I knew such photographs would be intrusive. Instead, my goal was to explore the spiritual and physical relationship between a morada and its environment. It was not by accident that the Brothers had picked sites that were spiritually powerful and aesthetically beautiful in which to build these sacred buildings. I have always wondered which came first—whether the place was a sacred site that called for a morada to be built there or whether the place became transformed after a morada was established.

Logistics dealt with, and having gained some cultural and historical knowledge of the moradas and the Brotherhood to guide me, I began to make photographs. Yet I sensed that something was lacking. I was learning—intellectually. But in order for the photographs to reveal the true depth of the Brotherhood and to be authentic, I needed to understand the Brotherhood on a heartfelt and personal level. In order for these images to reflect an intimate sense of the landscape and the religious experience that had shaped the Brothers, I needed to share in that experience as much as an outsider could.

It wasn't until I had experienced a transcendent moment in a morada that I understood what all this could mean and how it might indeed change a person. On the Thursday of Holy Week one year, I went up to a morada to spend the day with the Brothers. We were in the morada, praying the rosary and offering prayers for the sick and infirm in the village. There was nothing to lean on or against—we were upright, on

our knees. I was cold and tired. We prayed for hours. I watched the light stream in from the window, striking the *santos* (sacred images) on the altar. I knelt in a blur of melodic chanting voices, light, cold, and fatigue. I let go of myself and became just one man among others, with no goal but to be a part of the moment.

This and other experiences helped me understand how deeply the Brothers wanted their personal relationship with God to be real and heartfelt. The survey turned from a documentation project into a mission of personal discovery and appreciation.

During the years of the project, several members of the Brotherhood took me under their wings. They advised and guided me in achieving an understanding of their fellowship and their relationship to the structures they built. Several Brothers came to speak for me when I was called before the governing body of the Brotherhood, the *Mesa Directiva*, whose members wanted to question my motives. They were concerned about the Brotherhood's being sensationalized, used, or misrepresented. One of my supporters asked these Brothers, "Who are we to say that this man has not been called to do this work? He wants to share something real about us, even while he safeguards our privacy." Later, my friend Hermano Floyd Trujillo wrote me:

We have no record of what our morada here in our village looked like one hundred years ago. We have no record of what our morada looked like even ten years ago. The point I want to make is that we need to take pictures of moradas as a record of our history. I wish to tell you that what you are doing is not an invasion of our privacy but something that is helpful because, as you know, moradas change as time passes. Your photographs will be important to our own understanding of where we came from.

The project might have started with me, a photographer standing along

the side of the road pointing his camera at an old adobe building, but it became a labor of love and learning, an experience of community and acceptance, in ways I had never thought possible.

The three images that follow reveal, I believe, an essence of the Brotherhood and the moradas themselves. I sense a spirit of "otherness" in them, a numinous quality that runs deeper than mere description and exists beyond the photographer, the lens, the film, and the subject being photographed.

Retablos are usually of saints, but here, santero Charlie Carrillo shows what's important to me when making photographs—the land of New Mexico and the beautiful clouds overhead.

CRUCIFORM PENITENTE MORADA AND
FAMILY CHAPEL ON HILL, NEW MEXICO, 1990

CRAIG VARJABEDIAN

I HAD BEEN SEARCHING FOR MONTHS TO FIND THIS morada. I had only limited information to confirm its existence. One day, while driving with Cindy, my assistant, I noticed a small chapel on a hill set back from the road. I turned down an unmarked, single-lane dirt road, looking for a place to make a photograph.

I had set up my eight-by-ten view camera on a tripod and was focusing the camera when a truck pulled up. In it were two men. The older man stepped out of the truck. "Do you know that you are on private land?"

In my enthusiasm, I had not seen a NO TRESPASSING sign along the road. I introduced myself, apologized, and said I would pack up immediately. I had just been overwhelmed by the beauty of the scene.

"No, wait a minute," he said. "What are you doing?"

We started talking and soon were on a first-name basis—Craig and Cindy and Leopoldo and Martín, Leopoldo's son. I explained the documentary work I was undertaking. After an hour or so, Leopoldo invited us to his house for a cup of coffee. So began a long friendship with Leopoldo and his son Martín that lasted until they both passed on.

Sitting around the table, by the wood stove, we talked about the area, the Brotherhood, life in the village. Leopoldo and Martín asked lots of questions about the survey. They had met Tom and Margil Lyons years before during their photographic visits and remembered them. During the course of the conversation, I mentioned how I had been searching for weeks for a particular morada. "I've been looking for a morada Margil spoke about, but no one seems to know where it is," I said to Martín. "It's cross shaped and supposed to be in this area. I've heard it has stars painted on the ceiling of the chapel. Have either of you heard of it?"

Leopoldo, sitting there with a growing smile on his face, said, "I can show you where it is."

About half a mile up the little road, off in the distance, beyond a barbed-wire gate, was the cruciform morada. Leopoldo told us, with evident emotion, that it had been built many years ago by his two grandfathers. As a little boy, Leopoldo had helped make adobe bricks for the building. He had been told, "That Man up there, He sees what you are doing and is very grateful for it."

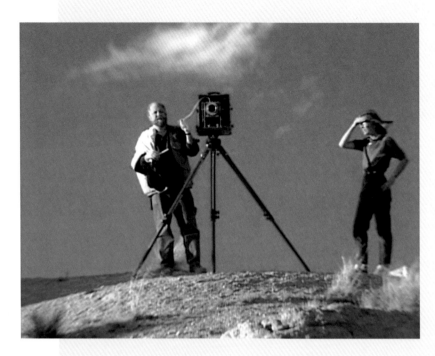

Cindy Lane and I climbed to the top of this hill—take after take
—while shooting the *¡Colores!* television program *En Divina Luz*
(In Divine Light) produced by KNME-TV, the PBS affiliate in
Albuquerque. The program won an Emmy in 1991.

This photograph was made about a year after Cindy and I met Leopoldo and Martín. That day was full of ever-changing weather: sun, then rain, then a rainbow, then sun, then clouds again. I was up on the hill, being filmed for a PBS documentary about the project, a collaboration between the television producer Karl Kernberger and me. It was shown on *¡Colores!*, a cultural affairs program produced by KNME-TV, the PBS affiliate in Albuquerque. The program has aired many times across the United States and won an Emmy in 1991.

I had set up my camera so that viewers could see how a view camera worked. Karl wanted to show how I had to assemble my camera equipment: set up the tripod, attach the camera, unfold it, lock it in place, attach a lens, focus while under a dark cloth, and insert the film holder. I was talking to the television camera about my photographic work while keeping an eye on the scene behind me. Suddenly the sun broke through the enveloping clouds.

New Mexico is like no other place I have ever photographed. The quality of light here is magical. It not only illuminates the stark beauty around us but also articulates depth and distance. Light "describes" by revealing the essence of a subject—not just the surface features but sometimes the deeper and more meaningful aspects seen when the photographer is patient and willing to wait.

Light has taught me a lot. There is a right time for any subject, if things are illuminated the way they need to be. In this photograph, the light defines the planes of the scene: the light gray of the space in front of the morada, the highlights of the roof, which emphasize the cross shape of the building, the darker gray of the field beyond, the dark trees separating the field from the hills, and the light-flushed hills and mountains in the distance, up to the horizon—the sky and clouds. What makes the photograph work for me is the light on the roof and the shaft of light on the ground, bordered by dark shadows, a light that says, "This is where you must look, this is what you must seek." So in the middle of the filming, I said, "I need to stop and make a photograph of this." And I did. Leopoldo and Martín and the whole crew were there to witness the moment.

The scene disappeared as quickly as it came. It began to rain. We packed up hurriedly, especially when we saw lightning. But as we disassembled cameras and tripods, someone said, "Look up," and there in the sky, above the morada, shone a rainbow.

This is the photograph I made the morning I first met
Leopoldo Martinez and his son Martín.

(*Santa Rita Chapel, Chimayo, New Mexico, 1989.*)

On the hill above the Penitente morada is the Santa
Rita Chapel. The story about this chapel is perhaps
more legend than fact, but to tell the truth, I like the
legend best.

Leopoldo had two grandfathers—Pedro Fresquez and
E. O. Martinez. They built the Cruciform Morada. But
before this, Pedro was involved in building something
else—a small chapel on a hill above his house. It
began like this—Pedro was engaged to the most
beautiful woman in Chimayo. He had to leave her
during World War I, to serve in the infantry in Italy.
During a deadly barrage from the enemy, he took
refuge in a chapel named for Santa Rita. He prayed
for delivery and promised if he survived, he'd build a
chapel to honor Santa Rita. He did survive the war. He
came back home, only to find that the most beautiful
woman in Chimayo had taken up with another
man. He turned to drink and he forgot his promise
to build the chapel. One day, wandering home from
the cantina, he fell into a ditch. When he awoke,
he looked around and saw the sun shining, heard
the wind slipping through cottonwood leaves, and
smelled pinon and sage. He remembered his promise.
He ran to his home, hitched up his horses, and went
to town for the lumber. Up on the hill by his house, he
began to build the chapel for Santa Rita. And his life
changed. He felt at peace again. The most beautiful
woman in Chimayo came back to him. They married
and began their family. And above their house, the
Santa Rita chapel protected them all.

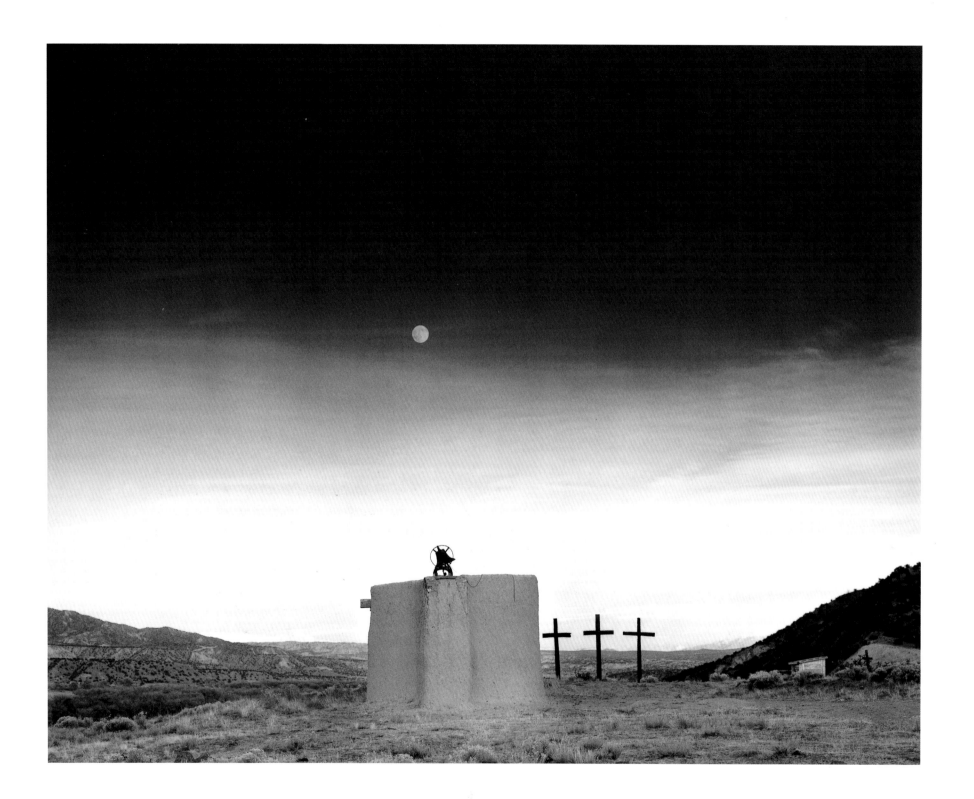

MOONRISE OVER PENITENTE MORADA
DUSK, LATE AUTUMN, NEW MEXICO, 1991

CRAIG VARJABEDIAN

SOMETIMES, TO FIND A PHOTOGRAPH (OR FOR A PHOTOGRAPH TO find me) I get in my truck and drive. I follow the light and wait to see where it will take me. That's how I found Cañoncito at Apache Canyon and that's how I found this morada.

On a wintry day in April, I was driving into a small village north of Santa Fe. The road wound up and around a cluster of houses and brought me to the top of a hill overlooking the village and its fields. There I saw a building that I later learned was a Penitente morada. It was a large, simple, solid edifice, emitting a power and a presence. Three crosses stood beside it. A bell topped the roof, exposed to the elements. I sat quietly and let the stillness absorb me. I fell into a meditative state in which emotion seemed to take over perception.

The light and the sky were spectacular. Swirling clouds sometimes obscured the setting sun. Snow began to fall, stinging my face. The sun emerged from below the clouds; the light illuminated the snow shower so that it looked like millions of tiny shooting stars. The stars heralded night, and the symbol of the night, the moon, rose even as the sun was setting.

Spellbound, I watched the moon rise over the chapel. I followed its path with my eyes, its light flickering through the pockets of clear sky. And

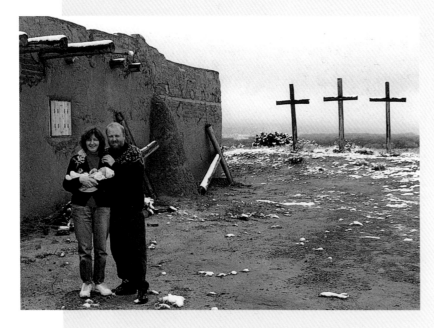

My daughter Rebekkah was blessed by the
Penitente Brothers who belong to this morada shortly
after her birth. This picture of Rebekkah, my wife Kathy,
and me was made shortly after the ceremony.

(Photograph by Charles Strong.)

then, for an instant, time froze. The hills on either side of the morada, the three crosses beside it, the bell, and the ridge of clouds on the horizon were illuminated. The moon shimmered, a beacon in the sky, directly above the chapel. But the source of illumination seemed to me not the setting sun or the rising moon but the morada itself. I saw, in the midst of shapes and textures, a building glowing with its own inner source. This light gave warmth and peace, despite the cold and gusts of wind.

Afterward, when the light had disappeared, I walked away knowing that I needed to make a photograph that would allow me to share the depth and stark simplicity of this experience. But to do so, I had to be ready. I began to prepare. Starting in April 1991, I visited this morada monthly on the night of the full moon. I made diagrams showing where on the horizon the moon appeared and began its ascent. I noted the time when the moon was directly above the bell.

The building faces due east, the three crosses to its right, and is balanced between the slopes of the two anchoring hills. I wanted to make a photograph of the scene when the moon was directly over the bell, creating a tension between the two. My wife Kathy, Cindy Lane, and I searched astronomical charts for a time when the moon would rise sufficiently into the sky but when enough daylight was left to illuminate the landscape. We spent months charting and researching, consulting several sources for moonrise times because the point on the horizon from which the moon rises changes. The right conditions, we found, converged on only a couple of days each year.

While researching astronomical conditions, I also made exposure and development tests on various films and tried different photographic filters to determine the effect I wanted to achieve. I wanted to make a photograph that was consonant with what I had seen and felt the first evening I had been there.

I eventually figured out the right day and time to make the photograph: the twenty-first of November, at just about 5:00 P.M. The moon

was almost full. I arrived at the site early. Around 4:00 P.M. I set up my camera. I had previously figured out all the exposure calculations, the appropriate filter, and where to place the camera. I stood waiting, along with Cindy and Kathy.

At first the sky was a clear pale blue. Then, as the moon began to rise, a thin veil of clouds started to move across the sky. These weren't the dramatic clouds of that first visit but an obscuring haze. I watched it cover the horizon and thought, "Oh no, there goes my photograph." I watched the moon move through the mist, vague and veiled. Finally it reached the height at which I had seen it that April night.

And just then it escaped the fingers of cloud into the clear sky. Poised over the morada, the moon seemed to answer the clarion call of the bell with it own sudden, remarkable clarity. I had thirty seconds to make the photograph before the moon moved out of position.

Now, because this is New Mexico, fifteen of those seconds were taken up in shooing away the two black Labrador retriever puppies who decided to join us and were romping through the scene. Kathy and Cindy chased them, caught them, held them, and shouted, "Clear!" The moon stayed above the clouds, and I made the photograph. I yelled, "We've got it!" It was a wonderful release—we all applauded and cheered.

We drove home to Santa Fe with much anticipation. Once there, Cindy and I immediately went into the darkroom and developed the film. We looked at the negatives and smiled. All the calculations and hard work had paid off. If they hadn't, we would have had to wait months to try again.

All the planning in the world can make for a wonderful photograph. And all the planning in the world can be useless when nature (or puppies) behaves independently of the photographer's desires. This photograph was a gift. I planned for it long and thoroughly, but in the end I received a gift when the moon rose above the clouds and revealed a moment of serenity and joy.

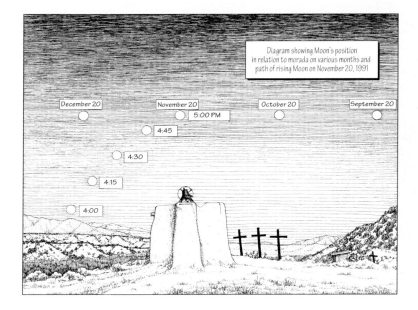

Diagram showing Moon's position in relation to morada on various months and path of rising Moon on November 20, 1991

December 20 · November 20 · October 20 · September 20

5:00 PM · 4:45 · 4:30 · 4:15 · 4:00

This photograph took a lot of planning. Here you can see the position of the moon in relationship to the morada over several months in 1991. Also note the moon's path on November 20th, the day the photograph was made.

(*Illustration by Lori Musil.*)

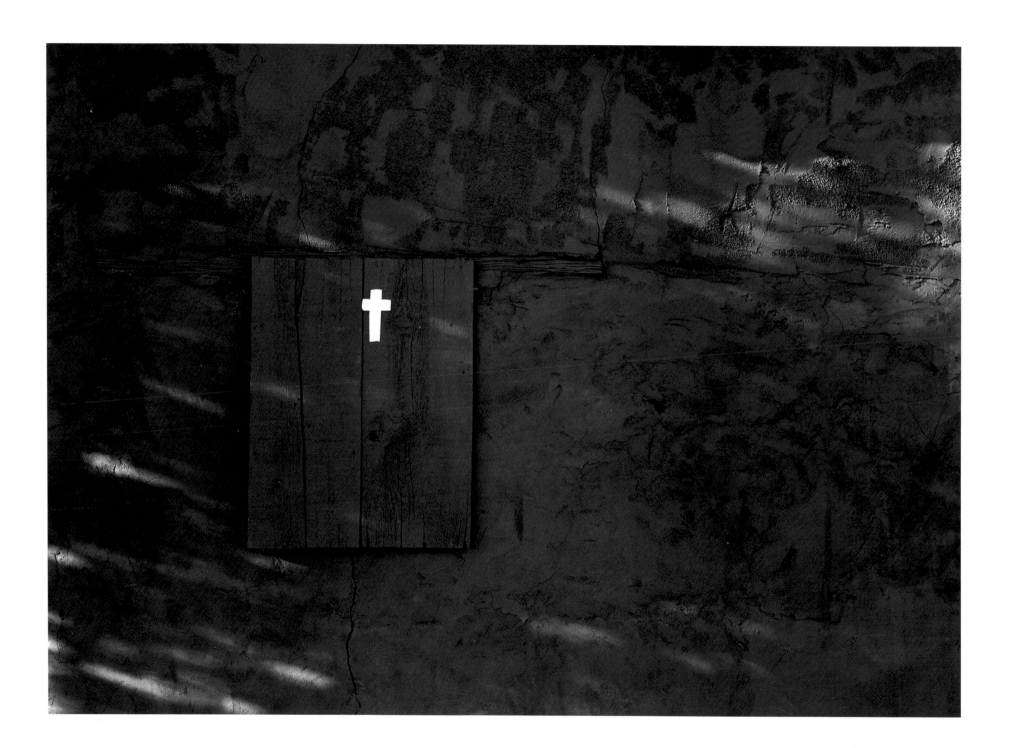

CROSS MADE OF PALM FROND ON PENITENTE MORADA, NEW MEXICO, 1993

CRAIG VARJABEDIAN

THIS PHOTOGRAPH, ALTHOUGH OF A SMALL DETAIL, IS memorable to me because it comes to represent the whole of my experience with the Penitente Brotherhood.

This particular morada was unusual because the Brothers had built a separate structure nearby for a kitchen. Often, the Brothers bring food to the morada after their *alabados* (hymns) and prayers, but at this one the food could be prepared on-site—a mystical combination of feeding the body, the mind, and the soul.

I made this photograph early in the morning, shortly after Holy Week—the week when the Brothers remember Christ's passion, death, and resurrection. The sky was clear—not a breath of wind. Everything that day seemed clearer and brighter than normal. I was photographing the morada, absorbing its presence, awed by the power I felt. A glimmer of white on the dark shutter on the kitchen building caught my eye. At first I thought a shape had been cut out of the wood and the light was shining through it. Then I looked closer.

The glimmer of white was a cross made from a palm frond—simple and humble. Yet this stark token of promise and redemption glowed on the dark wood more brightly and clearly than crosses I had seen in cathedrals. The cross suggests a mystery, something greater than us. It promises an understanding between the believer and the Holy presence, just as each morada represents the human soul's longing for a direct experience of the divine.

Intellectually, I knew I had an amazing picture: the bright cross on the dark, clove-colored wood, flickering light coming in through the juniper bushes on one side of the window. The small rays of light suggest something greater. The light makes one consider what occurs outside the photograph— its source and the potential for interpreting that source.

Spiritually, I had a sense of something falling into place. This handmade palm-frond cross, in its simplicity, in its vulnerability (it was stapled onto the wood), and in its strength, represented the intimate relationship between the Hermanos and their Christ and God. The morada was part of a larger picture in which men of faith joined to create a way of life that, every day and with every action, celebrated this relationship. The cross beckoned and reminded me that all of this was based on the simplest of relationships: love.

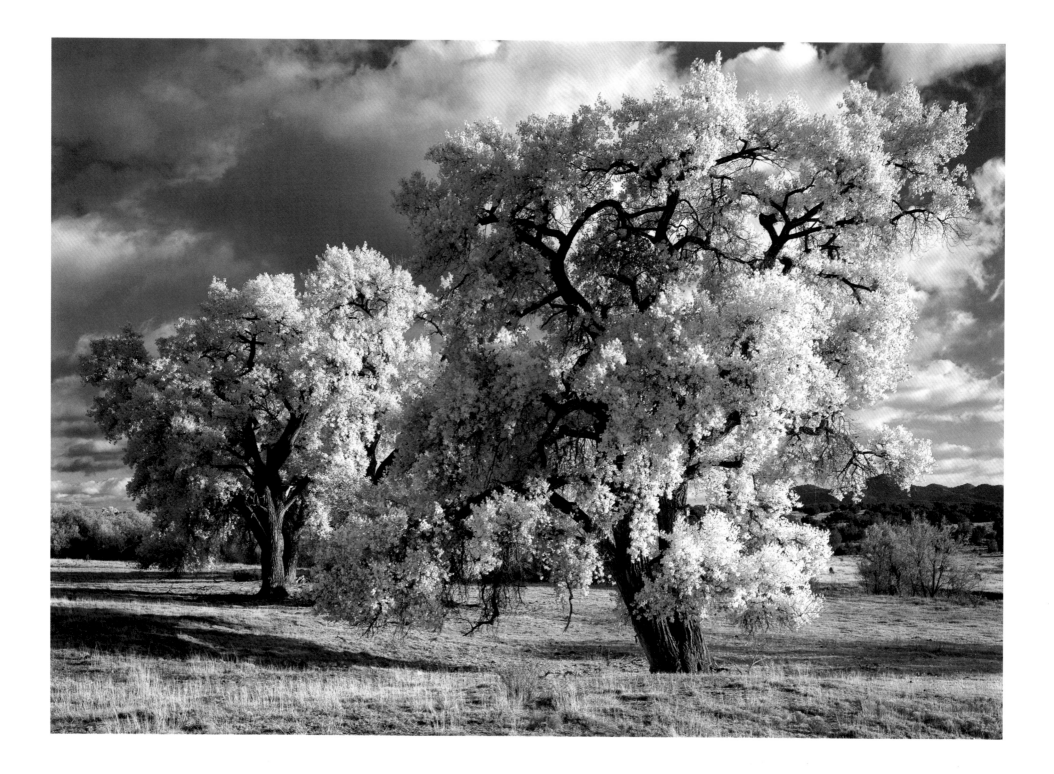

COTTONWOOD TREES NO. 5
AUTUMN, NEAR LA CIENEGA, NEW MEXICO, 1996

. . . the bosque itself speaks to the heart. The cottonwood is an icon of the West. Its arching canopy offers shelter and shade, in a land where both are scarce. Its furrowed bole stands fast against restless skies. Most important, the cottonwood signals water amid dryness. And its fat leaves, the size of a child's hand, applaud the slightest breeze with a sound like rain.

—William deBuys, "One Hundred Years of Change"

ROBIN JONES

THE COTTONWOOD—SCIENTIFIC NAME *Populus deltoides* —is a tree native to New Mexico. Needing water, it thrives best in moist places: on riverbanks and in the bosque, or riparian forest. One hundred years ago, when weary travelers spotted the tall, shining green head of a cottonwood, they knew that water was within reach. Today, one of New Mexico's most glorious autumn sights is a trail of trees, golden and yellow, following the line of a creek or river.

Cottonwoods can rise fifty to seventy feet high and have circumferences of nine to ten feet. From these massive trunks the trees branch out and produce radiant crowns of leaves in spring and summer. In the fall, leaves of gold rustle and sing in the breeze. A female cottonwood produces fluffy white seeds (hence the name) early in the summer. The seeds are carried away by the wind and must land on moist soil to survive. The cottonwood is a fast-growing tree and can live to be more than one hundred years old.

Cottonwoods are important to those who live here, particularly to Native Americans and the Hispanic community. Members of both groups carve figures out of cottonwood roots—katsina dolls and bultos (statues of saints). These figures represent power, encourage prayer, and promise strength. The roots are good carving material, and because they carry water, they can be considered the tree's life-bringer, just as the figures into which they are carved represent ways of life that support and nurture a people.

To the Hopis and other Pueblo Indians, katsinas are spirits, animal or human, that help a community understand how to live. As spirits, the katsinas demonstrate wisdom, bravery, power, and humor. In more earthly fashion, they are embodied by costumed dancers who perform in traditional ceremonies in which the community participates. The dancers demonstrate appropriate (and inappropriate) behavior. The

different katsina spirits are represented through small cottonwood carvings, decorated and painted. The cottonwood root, as a carrier of water to the tree, became as sacred as water itself to Native Americans.

When the Spanish colonists came to New Mexico, they were intent on converting the Native Americans to Catholicism. Finding similarities between katsina figures and their own images of Catholic faith—santos, sacred images—they, too, began to carve those images from cottonwood. Images of the Virgin Mary, Christ, the saints, and angels were fashioned as bultos (carved and painted statues). Bultos could be found in churches as well as in private homes and Penitente moradas.

CRAIG VARJABEDIAN

I am a transplant to New Mexico, originally from Canada. My love for this landscape began through a chance meeting with the photographer Ansel Adams. We met when I was a teenager, and later I attended one of his workshops in California. Adams urged me to travel through New Mexico, which I did while in my twenties. Like most twenty-year-olds, I was having an adventure, meeting new people, exploring, and often sleeping in my car to save money. I remember that I parked my car one night on the Santa Fe plaza. Waking early, I watched the light from the sun rise behind the Sangre de Cristo Mountains, illuminating the predawn sky. Transfixed by the richness and clarity of the light, I fell in love with New Mexico.

The glow of that light with the leaves makes cottonwoods special to me. This stand of cottonwoods is probably the most beautiful one I've ever found. These trees leave me breathless. There's something quintessential about cottonwoods—their cycle of being and becoming. I began to photograph this stand every year in an attempt to make a collective portrait of its trees. I'd drive down the road, park by the side, and set up my tripod and camera by the fence line. I've been photographing these trees now for more than fifteen years. I visit them over and over again—I can't view this scene enough. And because I return to it, I've developed a deeper familiarity with it and understanding of it. This is true for many of my photographs. I've gone back many times to a certain place to make new photographs, because a place can always show you something different. And by visiting a site repeatedly, I get to know when the light might best reveal the subject.

I call this image a portrait because I sense that trees have a resemblance to people. Trees have different expressions, different looks for different times of the day and year. Because I had witnessed so many of the expressions of these trees, I wanted to collect them in a series of pictures. I thought of Alfred Steiglitz, who kept photographing Georgia O'Keeffe over time and across a range of emotions; similarly, I wanted make photographs of these trees under different conditions and appearances. There are always changes, if not in the trees themselves, then in their environment. And the photographer changes, too; after fifteen years I know I'm different from the man who first began to photograph these trees.

The day I made this photograph, the leaves were flaming. The light seemed to emanate from the trees, not from the sun.

People sometimes ask if I used infrared film to make this picture, because the leaves appear white in the photograph, but I didn't. I used normal black-and-white film with a Wratten #15 yellow/orange filter that I knew would darken the sky and at the same time accentuate the glowing quality of the leaves. I made the image in the late afternoon, a time that seems to best reveal the trees' grandeur.

These triumphant, glowing cottonwoods heralded a new life for me as a father. A week after this photograph was made, our daughter, Rebekkah, was born. Unofficially, Kathy and I call this photograph "Rebekkah's Trees." We didn't know whether she would be a girl or a boy, nor did it matter—we just wanted a healthy, happy baby. We got a little girl as strong and gorgeous as the trees. This photograph mirrors all the joy and

excitement we felt at the time of her birth and the new journey our families, Kathy's and mine, were about to take together.

My family heritage is Armenian. Kathy can trace her family back to the early Pilgrims. We live in New Mexico, surrounded by a diverse community, learning much from the past about how to live in the present and plan for the future. I may not have a santo or a katsina doll to teach me, but I can look to the cottonwood trees for lessons. I recognize that the roots are needed to sustain the branches. I know the seeds travel far and need special nurturing to grow. I understand that future trees will produce seeds and that these seeds in their turn will travel to produce new trees. I have become, like the tree roots, the supporter and nurturer of my daughter. I like to think that cottonwoods nurture us all, just as a santo or katsina might, just as a mother or a father will.

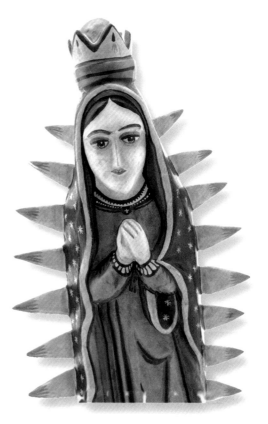

Traditional New Mexico bultos are carved from the roots of cottonwood trees. Charlie Carrillo is a well-known *santero* (saint maker) who carved and painted this bulto of Our Lady of Guadalupe.

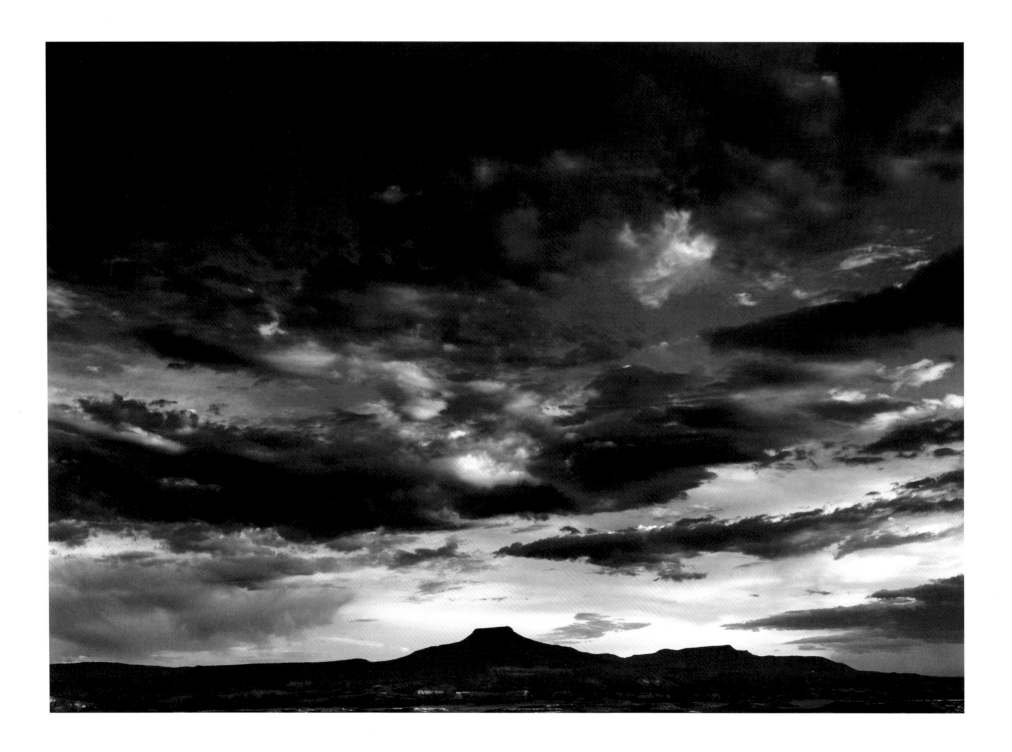

CERRO PEDERNAL NO. 2, SUNSET
ABIQUIU, NEW MEXICO, 1996

ROBIN JONES

NEW MEXICO'S CERRO PEDERNAL RISES, A FLAT BUTTE, out of the northern Jemez Mountains. The outline is that of a range of hills joining at a summit, a flat mesa stretched under the sky, surrounded by no other peak, no other height but that of light and shadow. Pedernal is multicolored— red, yellow, purple, gray. Writers see color differently: crimson as the sun glows red on the slopes; amber where soil and rock meet in a mixture of age and change; a lavender foretelling the shadows of the afternoon and early twilight; thundercloud gray that rushes over the mesa, transforming the land from diamond sparkles and life back to desert stillness again.

God or geological forces may make mountains, but so do poets and painters, casting or recasting them as images with meaning and depth beyond the first casual look. Georgia O'Keeffe did this with the Pedernal. She painted it simply, as it was, the blue shadows of the mountain mirroring the blue, cloud-covered sky (*Blue and Yellow,* 1941). The tinge of apricot on the upper meadows is a rounded mist of cottonwoods. The distance from the foreground to the top of the Pedernal is measured not by footfall or mile marker but by the eye, wandering from color to color and horizon to horizon.

O'Keeffe painted the Pedernal in juxtaposition with its environment: the red mounded cliffs near her home lining up a portrait of the Pedernal in its blue and free-ranging length (*Pedernal and Red Hills,* 1936). She saw it, a blue and distant faraway, behind the aged, blackened tree branch that supports a deer skull, its antlers curling, winged shapes in the sky (*Deer Skull with Pedernal,* 1936). She glimpsed it from a bone socket, its curving orbit of color leading the eye to that flint mound from which comes Pedernal chert—a white to translucent stone stained with red, yellow, and black. Bone and stone, both subjects O'Keeffe painted in addition to her favorite mountain, show the rhythm of reality, the cycle of change. In *Pelvis with Pedernal* (1943), the hollowed bone is sparked by distant light, foreshadowing and cradling the distant smaller mountain—but neither supersedes the other. Both are remnants of mightier moments.

Perhaps it was this notion of change, a lasting and final change, that prompted one of her most meaningful pieces, *Ladder to the Moon.* O'Keeffe wrote of the ladder at the Ghost Ranch house that she would climb it "to look at the world all

'round." She had been thinking of painting the ladder and one night saw the ladder, the sky, the Pedernal—a dark edge of the sky—and the white moon. *Ladder to the Moon* is the intense and eloquent reach to beyond, to forever, to infinity.

When O'Keeffe died, she was cremated. Her ashes were taken to the top of the Pedernal and given to the wind and sky.

CRAIG VARJABEDIAN

Ghost Ranch, New Mexico, is a magnificent yet challenging place to photograph. It's big and beautiful. But much of it had already been impressed upon my mind by the painter Georgia O'Keeffe. In the beginning, walking along the cliffs, I'd feel a lingering sense that I had seen this somewhere before. Then I'd realize that O'Keeffe had painted here. It wasn't recognition so much as it was remembrance. When I began making photographs at Ghost Ranch, I sometimes hesitated. I couldn't see the intended image by itself—only as something influenced by O'Keeffe.

I didn't want to make photographs that resembled her paintings; I wanted to photograph the spirit of the place that had moved her. I wanted to reveal in my photographs the essence of a particular moment that held me, as I thought it might have held her.

I had to spend time there. I had to walk it. I had to wander around and lose myself. I had to fall in love with this place.

Eventually, after hiking the many miles of Ghost Ranch, I began see and feel the space, depth, and light that might have inspired O'Keeffe. I began to feel more at ease at the ranch, more as if I belonged there as an artist, not just as a visitor or one of O'Keeffe's many admirers. The place revealed itself to me when I slowed down, paid attention, and quieted my mind.

When O'Keeffe first moved there in the late 1930s, she, too, was learning how to see the West. She thought a great deal about space and how to fill it. In this she may have been especially influenced by one of her earlier teachers, Arthur Wesley Dow, who specialized in Asian art. Dow admonished his students to "fill a space beautifully."

This idea helped me as well. Many students work with rules of composition that attempt to define space in a formalized way. But composition is not about a rigid set of rules. Photographer Edward Weston said about composition that "it's the strongest way of seeing." Art is often taught as if there are rules behind it. I suspect there is a degree to which one can teach art. But there's also a point at which the artist must take a leap from form to inspiration. For example, one of the many compositional rules is that you shouldn't place an object in the center of a frame. But I sometimes like to place the subject in the center of the frame. It tells the viewer that the photographer believes the subject has significance.

I am unwilling to allow any rule to define how I make photographs. I know it looks right when all the spaces and relationships and tones are in balance and a complete whole coalesces. That's where the mystery can happen, too. Sometimes, when it all comes together, there's a deeper response that goes beyond what I do and beyond the subject to strike profoundly at something inside. Exciting, mystical, and wonderful photographs are made when this conjunction happens.

Intuition is more important for me than formula. If I labor to compose a photograph on the basis of preconceived ideas—to force objects to find a place within the rectangle of my camera's frame—I seldom succeed. The best pictures I make are the ones for which I have somehow landed on the precise place where the magic happens.

Over the years I've made many photographs of the Cerro Pedernal. I love to stop and watch the light dance across it. It has such a commanding presence. You can see it from Taos, almost sixty miles away. My photographs of it were OK. But I hadn't made an image that moved me as

much as the Pedernal moved O'Keeffe, who claimed that God would give it to her if she painted it enough.

But one night, heading into the sunset, I was driving alongside the mountain and saw this magnificent array of clouds and light towering over it. It seemed that the Pedernal was orchestrating the sky. The flat top of the mountain reached up as if to direct the rolling convergence of light and air. The wondrous tension between the solidity of the mountain and the fluid movement of the clouds connected them.

I had a feeling that this scene was an apparition that would exist only briefly, and I had just minutes to make the image. I stopped and got out my camera, set it up as quickly as I could, and made several exposures.

One thing I am sure about when making photographs is that I am not in control of everything. That's photography. There are some things I can control, such as how long to expose and develop the film and which filter to use to achieve a certain effect. But the outcome, the final picture, more often than not is a gift, a moment of light and substance that just floors you. You can only hope to release the shutter at the right time as everything comes together.

I knew I had made a powerful photograph. Intellectually, I knew I was making a picture about space and the relationships of the things within that space. Even though the solid object, the Pedernal, is so dominant, I didn't have to try to show how big it was—the sky was already doing that. Emotionally, I was seeing what the French photographer Henri Cartier-Bresson called "a rhythm in the world of real things," and I knew intuitively that I was revealing that rhythm.

On that evening I made two photographs that I love. When I saw the first one in the darkroom, I said, "Oh my God." Because that's what I saw—in the clouds, I could see a cross. My assistant, Cindy Lane, sees an angel. Either way, I put this print away for a while. I felt the image was loaded and would be too leading for viewers. I showed the second one instead. It was beautiful as well but didn't have the religious suggestion.

I wanted my photograph of the Pedernal to be itself; I didn't want what O'Keeffe called "the veil of Catholicism" to unduly influence the viewer. But every time I returned to the first photograph, the one reproduced on page 24—the one with the cross—I recognized that it was much more powerful than the one below. If good art comes from an emotional place inside the person who made it, then this "sacred" photograph creates an emotional response that is much more satisfying to me.

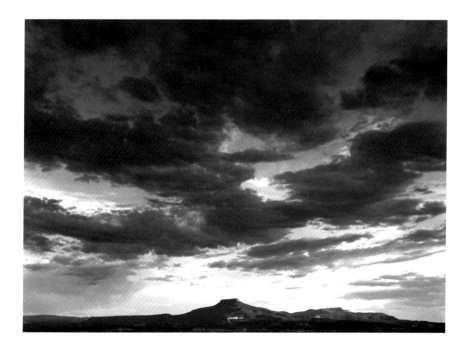

For a long time I showed this version of the image I made of the Cerro Pedernal. *Mea Culpa!*

(*Cerro Pedernal No. 1, Abiquiu, New Mexico, 1996.*)

THE MOST REVEREND MICHAEL J. SHEEHAN, ARCHBISHOP OF SANTA FE
EL RITO, NEW MEXICO, 1996

I really don't feel like a newcomer since I have become a part of the four-hundred-year-old presence in New Mexico. I drink of the same spiritual waters that those first settlers who came here in 1598 drank of. We still celebrate Mass in some of the earliest adobe churches that have survived since the early 1600s, such as San Miguel Church in Santa Fe and Saint Augustine Church in Isleta Pueblo. I am part of a continuum that has been here four hundred years and with God's help will continue on in the years to come. I feel very much at home here.

—Archbishop Michael J. Sheehan,
introduction to *By the Grace of Light*

CRAIG VARJABEDIAN

THE MOST REVEREND ARCHBISHOP MICHAEL J. SHEEHAN CAME TO New Mexico in 1993 to become the eleventh archbishop of Santa Fe. He remembers this as a painful time for the local church, which was reeling from allegations of misconduct by Catholic clergymen. When Sheehan landed at the Albuquerque airport, his first message was that "everyone was invited to the table," a call reminiscent of Christ's exhortation for all to come and worship together. Sheehan focused on humans' ability to integrate life and faith—to renew religious ties through culture, history, and individual strength.

I first met Archbishop Sheehan during a symposium about the Penitente Brotherhood. He impressed me as a man who didn't sit around and wait for people to come to him; he went out and ministered to them. And he's from west Texas, so he speaks Spanish fluently. Later, I got to know him while working on the project *By the Grace of Light: Images of Faith from Catholic New Mexico,* a series of photographs commemorating the four-hundredth anniversary of the Catholic Church in New Mexico.

When I decided to begin *By the Grace of Light,* I scheduled an appointment to talk to the archbishop. I knew I had already made several good images for the book, but I needed to understand their context within the whole of the Catholic faith. The archbishop represents tradition and must be able to keep that tradition alive in the contemporary world. Without Archbishop Sheehan's involvement, the project would lack the authoritative presence of a true leader of the Catholic Church. Meeting him in his office, I found him completely supportive. He gave me a letter asking people to assist me. I was able to make some photographs that might have been more difficult without his "blessing."

The better I got to know Archbishop Sheehan, the more I wanted to photograph him. He had become more than a representative of the church to me. He was also a remarkable and insightful person. I wanted others to have a chance to know the man, not the office. We were at dinner one night when I said, "You know, Archbishop Michael, I think we need a photograph of you for this project." He chuckled and said, "Oh, yes, sure." Perhaps his mind went to his official portrait—a color photograph of him in full vestments with miter and crozier, against a simple background. I didn't feel that this photograph revealed anything deeper about the man I was getting to know.

That started me thinking. I had seen the archival photographs of previous archbishops, such as Jean Baptiste Lamy and James P. Davis, all looking very solemn. I wanted a picture that showed Archbishop Sheehan as a man of the people.

After some time, I imagined an unusual and slightly whimsical photograph, an image of the archbishop with his flock—literally, a flock of sheep. Sheep are central to biblical symbolism and stories. They have also been important historically in northern New Mexico, where many people make their living raising sheep for meat or wool. I wanted to show the archbishop as a part of this region and this community. And I suppose that from my youth I had pictures in my mind of Christ holding a lamb.

The archbishop demurred at first, but I'm afraid I just kept presenting this idea until he eventually agreed to think it over. Finally he said he'd give it a try.

By now, however, there were no sheep around. Most herders in New Mexico take their flocks up to higher elevations to graze in warm weather, bringing them back down in cold weather. To find sheep now, we'd have to hike up a mountain, with my camera gear and the archbishop's robes, track down the sheep, get them into a meadow, and try to persuade them to gather around the archbishop. I didn't think the archbishop would be that willing.

So Cindy Lane and I started searching, trying to find someone with sheep at a lower elevation. Luckily, we got connected to a man with a small herd he hadn't yet moved. He lived in El Rito, a village near Abiquiu. I drove up there with my friend Floyd Trujillo and we knocked on his door. He was a bit skeptical at first, but he gave us permission to photograph his sheep in their little field behind his house.

The following week, I drove to El Rito with the archbishop and met up with Floyd, who came to supply moral support as well as animal handling services. The archbishop dressed in his vestments and walked out into the field. With his miter on his head and crozier in hand, he stood there looking slightly bemused. The sheep didn't seem to mind him, but they wouldn't get close to him, either. Indeed, whenever the wind blew,

his robes fluttered and the sheep moved farther away. Then Floyd, being prepared, walked in and scattered corn in a circle around the archbishop. You can see the light circle of grain around him in the photograph. Soon we had a small but willing flock around him, munching contentedly.

In the meantime, I had figured out that I needed to be much higher than my subjects in order to convey a sense of the sheep gathering around the archbishop. I climbed onto the cab of the truck, but that wasn't high enough. Floyd, true to form, had brought along a ladder, just in case. It was an old apple-picking ladder and not entirely stable. We stood it up at its rickety best, and I shouldered my gear and inched my way up. I stood near the top of the ladder, focusing my camera on the archbishop and the skittery sheep, wobbling back and forth almost ten feet above the ground. Down below the sheep were milling around the corn. The archbishop was trying to keep his robes clean, avoid bumping into the sheep, and look up at me. Floyd was standing off to the side getting ready to rescue either me or the archbishop. I made several pictures, but this one of the arch-bishop smiling I like best. I had told him a joke just seconds before releas-ing the shutter.

I know the archbishop had been hesitant during all this, but after-ward I was told that he showed the photograph to newly ordained priests to remind them that "you can't expect the parishioners to come to you. You've got to go out and meet them." This photograph shows Archbishop Sheehan as himself—as a holy man, not an office.

El Rito is a small town, and we were under much observation during this shoot. A woman came up afterward to meet us, and we took a photo-graph of her with her granddaughter and the archbishop. This is her story:

"Grandma, the archbishop is standing outside in the neighbor's sheep field!"

This is how my granddaughter greets me, getting off the school bus. I'm doing dishes, the laundry needs to be hung up to dry, and I

Floyd Trujillo with Archbishop Sheehan
(and a kitten who wandered into the scene)
at the end of the photo shoot.

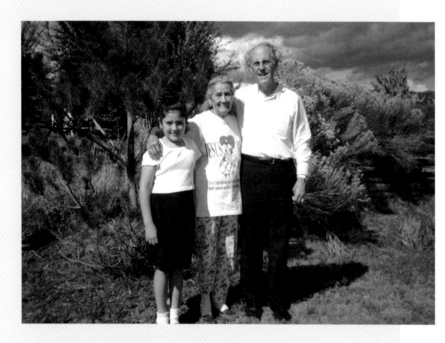

After I had made his formal portrait, I made a
photograph of Archbishop Sheehan with members
of the Archuleta family from next door.

know she has a big project for school to work on, so I figure she's
trying to distract me. But Díos mío, don't bring the archbishop
into this!

"Hijita, don't you tell fibs like that to me. You go to your room!"
I tell her.

But her sister, following her in, blurts out the same thing: "But
Grandma, he is! The archbishop is outside. He's got the sheep all
around him."

This is too much. I march to the window to look out. Boy, am I
going to tell them off for such a story.

And there is the archbishop, standing out in my neighbor's
sheep field. He's in his robe and carrying his crozier, and he's talk-
ing to a man who is wobbling way up on a ladder. I don't know
who's crazy, them or me.

So we all go outside. What would you do? I'm in my jeans and a
T-shirt, the girls are in their school clothes, the house is a mess, and
the archbishop is outside all dressed up—of course we go outside.

He's standing out in the sheep pen. He's got two men with him,
a sandy-haired man with a camera, and an older man with black
hair and a mustache. I'm a little shy about approaching, but the
archbishop smiles at the girls and me and says hello and explains
that this is just a photography session, and I say that's fine, and then
he introduces the sandy-haired man as Craig and the black-haired
man as Floyd. Floyd grins at me and the girls, and Craig says "Hi"
and makes a sort of "hello" gesture as he wobbles on the ladder.

The sheep are wandering around, bleating, making a mess, and
I'm scared the archbishop will step in something or trail his robes
in something. The girls are giggling, Floyd is sighing and shaking
his head, looking down at the ground, the archbishop is sighing,
shaking his head and looking up at the sky, and Craig is still peering
through his camera.

"What's wrong?" I ask Floyd.

"Well, the sheep, they don't seem to want to be around the archbishop," he says, and the archbishop looks kind of sheepish himself and I'm not surprised, because why would the sheep want to be around that crozier? It looks dangerous.

But Floyd takes a bag of corn, dips his hand in, and walks around the archbishop, sprinkling a circle of corn around him. The sheep watch him and then figure out what he's doing, and they all make a move toward the archbishop. I think for a second they're going to run at him or knock him over, but no, they just gather around the archbishop and start to eat, their heads bowed. The archbishop stands real still, Craig says something to him that I can't hear, the archbishop grins, and the picture is taken!

Afterward, Craig takes a picture of me and my granddaughter and the archbishop. I'm a little embarrassed—I'm not dressed up, but then I figure, I've got on my "Jesus Loves Me" T-shirt—and what better shirt can you wear with the archbishop? Craig wants to know if I want the sheep in the picture, too, but no, I've got my girls—that's all the flock I can handle.

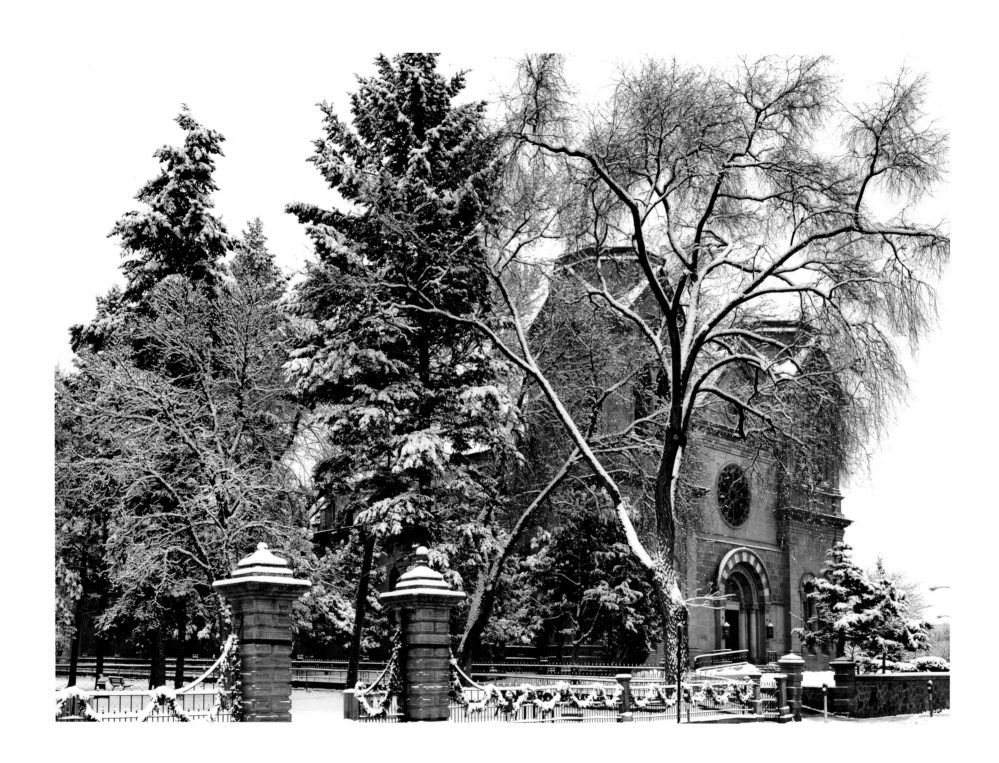

"Setting," Molny used to tell Father LaTour, "is accident. Either a building is a part of a place, or it is not. Once that kinship is there, time will only make it stronger."

—Willa Cather, *Death Comes for the Archbishop*

ROBIN JONES

SANTA FE'S PROPER NAME IS "LA VILLA REAL DE LA SANTA Fe de San Francisco de Asis," or "The Royal City of the Holy Faith of Saint Francis of Assisi." Such a connection to a holy saint must be acknowledged, and it was—by Jean Baptiste Lamy, the first archbishop of Santa Fe. Originally from France, Lamy was sent to Santa Fe as bishop in 1851, at the age of thirty-seven. He became archbishop in 1875 when the diocese was elevated to an archdiocese. In Santa Fe Lamy found the relationship between clergy and community uneasy, if not deplorable. He began a renewal of faith and a restructuring of the Catholic Church in the American West, a lifetime toil that was greeted with both joy and resistance.

A visible sign of Bishop Lamy's dedication to and hard work in New Mexico is the church he built, the Cathedral of St. Francis of Assisi, on Cathedral Place in Santa Fe. It replaced the more humble parish church of St. Francis, which had been founded by Spanish Franciscans in 1610. The new edifice stood a two- or three-minute walk from Bishop Lamy's residence. Willa Cather fictionalized Lamy in her novel *Death Comes for the Archbishop*, which chronicles his journey from France to the Southwest and his dream of establishing the cathedral in Santa Fe.

The cathedral, dedicated in 1886, might be seen as a palimpsest of the area's various time periods, building materials, and communities: older structures are enveloped by newer structures. Part of it—the Conquistador Chapel (1714), which houses La Conquistadora (Our Lady of Peace), the country's oldest Madonna figure—is built of adobe. Lamy himself and a more modern time are represented in the main structure, built of stone and stained glass (imported from France) in the French Romanesque style. The Blessed Sacrament Chapel, added in 1967, helps fill the needs of today's parishioners.

Known as "the cradle of Catholicism in the Southwest," St. Francis Cathedral has also been home and heart to many Santa Feans who have been baptized, married, mourned, and remembered there. It is a place where families have gathered to celebrate and worship for generations. In the summer of 2005, Pope

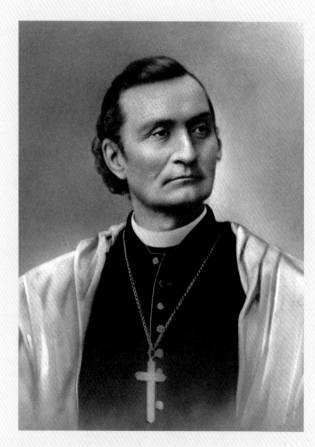

A rare portrait of Archbishop Jean Baptiste Lamy
as a young man. He was the first Archbishop of Santa Fe.

*(Courtesy of the Historic Artistic Patrimony and Archives,
Archdiocese of Santa Fe.)*

Benedict XVI elevated it to the rank of basilica. The Greek meaning of *basilica* is "royal hall," but in Christian terminology it means a place especially recognized and honored by the Holy Father. Now known as the Cathedral Basilica of St. Francis of Assisi, this historic and stately structure has been acknowledged for its leadership in the Catholic faith in the Southwest. Along with this honor, the Cathedral Basilica received a new coat of arms, an *umbrollino* (a yellow and red striped canopy traditionally used to cover the pope during visits), and a *tintinnabulum* (a handheld staff supporting a bell that is rung to announce the arrival of the pope). To apply for this status, officials had to submit answers to a 180 page questionnaire, an album of historical photographs, and a bibliography of works written about the cathedral.

One of Santa Fe's most lovely winter images is that of the cathedral in the middle of town, shrouded in snow, a flickering light scattering on the stained-glass rose window and the towers. During the nine days before Christmas, the congregation of the Cathedral Basilica of St. Francis of Assisi observes a New Mexico tradition called *Las Posadas*, a reenactment of Mary and Joseph's search for shelter. Each evening, Mary and Joseph—sometimes children dressed in robes, sometimes statues carried by children—set out to look for "a room at the inn." The procession represents the long, difficult journey the couple endured from Nazareth to Bethlehem. The children are accompanied by adults, musicians, and other children dressed as angels. At any door they knock upon, they are refused entrance. On the final day, Christmas Eve, the procession arrives at the church and Mary and Joseph are admitted, anticipating the birth of the Christ child.

This photograph of the cathedral is an intimation of kinship in landscape. The church fits into the plot of land allocated to it, but hidden within the edifice is the first parish church of St. Francis. Archbishop Lamy, wanting stone, not mud, had much of the old church torn down and the cathedral built around the adobe extremities. The cathedral hides its own origins. But it, too, is masked by the snow and the tall trees that stand sentinel beside it. It demonstrates a kinship with its natural surroundings—rock, earth, and trees. This relationship has

grown only stronger with time as additions have been made to it out of local rock: limestone from Arroyo Sais, volcanic rock from Cerro Mogino, and granite from the village of Lamy.

The cathedral bears evidence of other relationships. Above the main door you'll see the Hebrew symbol for God, or Yahweh. The story goes that Bishop Lamy, in raising funds to build the cathedral, went to every Catholic in the area. When they had given all they could, he went to the Jewish community and asked for help. It responded generously, supplying enough money to finish the construction—hence Bishop Lamy's tribute at the front door.

Lamy's abiding courtesy and humor is illustrated by a story quoted from Paul Horgan's biography of him, *Lamy of Santa Fe*:

In the Corpus Christi procession one year the marchers paused in Palace Avenue before the house of Willi Spiegelberg to rest. . . . They set the decorated and canopied litter of La Conquistadora on the street while they mopped their brows and chatted briefly. The smallest Spiegelberg child—a little girl of four or five, saw the tiny Madonna, and unobserved, ran out to take it up in her arms as she would a doll and happily returned to the house. The bearers went on their way, and not until they reached the cathedral did they notice that their Madonna had left them. Their astonishment was mixed with fear. . . . in the evening Flora Spiegelberg went to kiss her daughter good night and found the Madonna tucked neatly in her daughter's bed. . . . [She] flew to the archbishop's house to restore the figure with explanations and apologies. Lamy received all with "roars of laughter." . . . Comforted, she was able to go home in peace, though her child felt robbed of her new doll. Nothing more was heard of the affair until many months later "a beautifully dressed wax doll" came from Paris, with a note from the archbishop to the little girl to explain that it was "to replace the little Madonna."

My work as a photographer is not necessarily to record things as they are but to express through my images what it feels like to stand in a particular place at a particular time. I had decided that I wanted to make a winter picture of the cathedral and tried several times, only to be foiled by too little snow, wind blowing the snow off the trees, or automobiles parked at the parking meters in front of the building. Scant snowfall can be a problem in a desert setting like Santa Fe; it's rare that we have a snowy Christmas. Another difficulty in photographing a popular place is finding quiet and unpopulated moments.

When I made this image, I got up before dawn a couple of days before Christmas and headed to the Santa Fe plaza. Snow had been falling since about midnight, enough to dust the trees and the building while leaving the shapes and textures of the objects revealed. It was still snowing when I got there.

By sheer luck, it happened that the nearby hotel, La Fonda, was doing major renovation work and had closed off the street. This was my chance. I set up my camera and waited for just a little more light. Suddenly, the sawhorses blocking the streets were pulled away, and in drove the construction crew. They jumped out with their coffee and started setting up their gear, which included a large crane that they were going to move right in front of the cathedral.

Maybe it was something about the cathedral itself, standing so imposing and still under its faint blanket of snow. Maybe it was just the peacefulness of this early morning. But I looked at them and they looked at me, and they held off moving the crane into place until I had finished. This is the photograph I made.

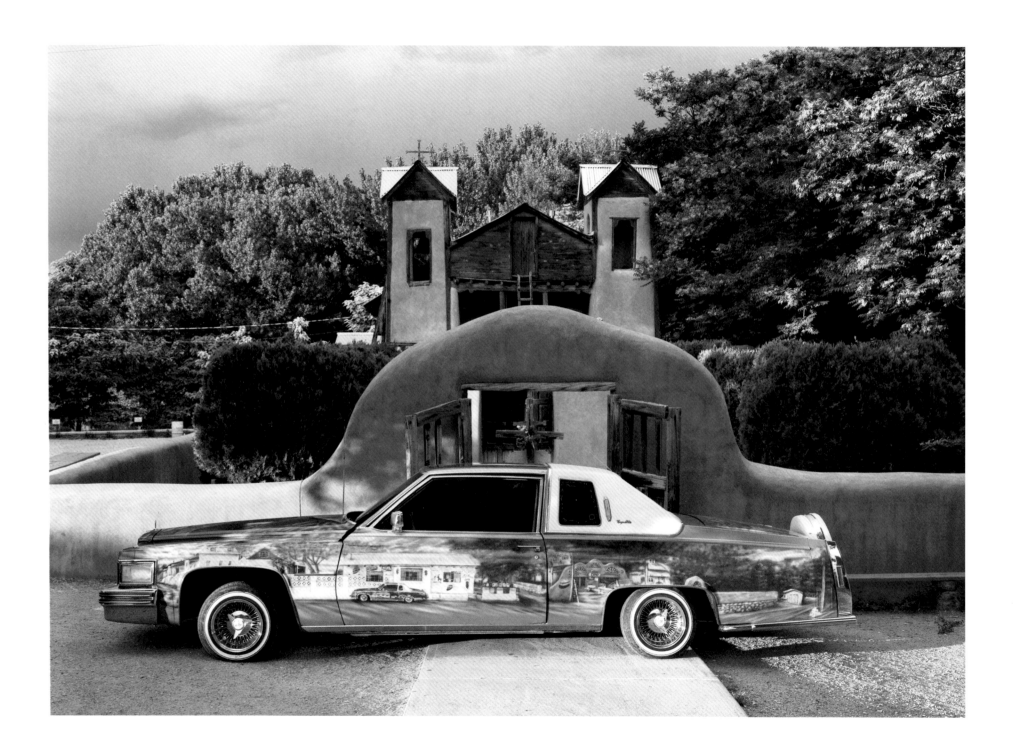

LOW-RIDER CADILLAC NAMED *CHIMAYO*
SANTUARIO DE CHIMAYO, CHIMAYO, NEW MEXICO, 1997

[A low rider is] a beautiful metal box which many call home. It doesn't matter if the manufacturer was Ford or General Motors, their executives in the suburbs of Detroit watching home movies, vacationing in weird Londons—when the metal is yours you put your mark on it. Buying something is only the first step, what you do to it is your name, your history of angles, your exaggeration, your mad paint for the grand scope of humanity. The urbanites will see them like butterflies with transmissions.

—Victor Hernández Cruz

CRAIG VARJABEDIAN

IT USED TO BE THAT OUT WEST, YOU WERE KNOWN BY THE HORSE you rode. Nowadays, that's translated into cars—and certainly in American culture, you and your car can be identified with each other. That's OK with me, having been fascinated by cars all my life. I guess I owe this to my dad. He's a mechanical engineer, and I learned a lot from him about mechanical things. Of course, when I was little I thought he was a train engineer—my mother had to teach me the difference. But I never really understood what my dad did until I visited a car factory in Windsor, Ontario, with my Cub Scout troop in the mid 1960s.

It was a Chrysler plant. Dad gave us the tour. What was impressive was

seeing how automobiles were made. We all watched in amazement as wheels were attached and engines dropped in. I could finally understand what my dad did for a living.

Cars have always been a part of my life. When my family moved to the United States from Canada, we lived outside Detroit. I have a soft spot for cars: even though I seldom photograph them, I like to keep up with what's new, and if there's a car show nearby, I like to go.

That's where I saw this car, which is named *Chimayo* and is owned by Victor Martínez. I saw it in a car show in Española and said, "Wow." It was a very quiet "wow," more like a prayer than an exclamation. This car had Victor's heart and soul in it and on it. Even though he drove it back and

forth to work every day, *Chimayo* was his baby, his masterpiece. It was a Cadillac, airbrushed on both sides with the familiar street scene of the village of Chimayo. It also had on it a precisely and lovingly rendered image of the historic church known as Santuario de Chimayo.

At the time, I was looking for concrete expressions of Catholic faith for the book *By the Grace of Light*. I wanted images of religion made manifest. This car, serendipitously, represented not only a driver but also the driver's family, town, community, and faith. I asked Victor if I could photograph his car, and he agreed.

Victor lived in Chimayo, so that's where we planned to meet. Because he worked days and needed the car, we would have only a small window of opportunity to photograph *Chimayo*.

I had no idea where I wanted to photograph the car until Victor and his nephew drove into the Santuario parking lot. Suddenly I had a vision, a mental picture, of the car in front of the Santuario gate. It was a wonderful juxtaposition: I loved the way the adobe walls mirrored the shape of the car. What a wonderful tribute to a holy place.

Victor's nephew pulled the car in, beaming as he did so, and I began to work. We created a bit of a stir. The church had closed and Father Roca had gone home, but tourists, visitors, and townsfolk started to come by and watch, interested and courteous. Some people even went home for their cameras! With all that good will and with twenty minutes of summer daylight left, I made this photograph. It is a once-in-a-lifetime image that would be difficult to reproduce, because there is now a concrete barrier in front of the gate.

The architect and designer Ludwig Mies van der Rohe once wrote that "God is in the details," and I extend his thought to *Chimayo* the car and the beautiful adobe churches of New Mexico. One might not think that a car could reflect faith, but it is the details of this car that demonstrate respect and devotion. Faith is also found in the church's adobe bricks, which are held together by straw, earth, water, duty, and devotion—even if the last two

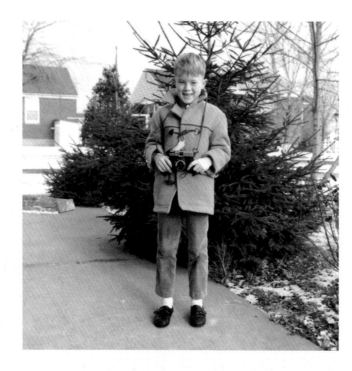

My dad made this picture of me with my Diana camera
in our backyard in Windsor, Ontario, Canada

(*Photograph by Suren Varjabedian.*)

are less obvious than the material elements. In this photograph, the Santuario and *Chimayo* form a contemporary and meaningful image of faith.

ROBIN JONES

El Santuario de Nuestro Señor de Esquípulas—the church at Chimayo—is the final point of pilgrimage during the holy week of Easter in New Mexico. Thousands drive, walk, crawl, or are carried to its walls, seeking succor, offering ex-votos (offerings of thanks for God's healing), or pledging their faith and hope to the sacred site. Police guard the roads, bonfires warm pilgrims, food and water are handed out to weary walkers. The curious, the faithful, the elderly, and the young are all part of a living tradition that depends on faith.

The village of Chimayo was established by Tewa Pueblo Indians, who named the town Tsimay, which means "good flaking stone." The Spanish community was established around 1690. The chapel itself was built in 1813 and is considered a most holy place. One story goes that a shepherd from Chimayo was tending his flock when he heard a bell ringing. It seemed to be coming from underground. The man left his sheep and began to dig. Eventually he unearthed a crucifix. He immediately took it to the priest, who carried it to the church in Santa Cruz. But that night the crucifix disappeared. The bell was heard ringing again from the same spot, and when the villagers investigated, the crucifix was back in the hole. They carried it back to Santa Cruz, but again that night it vanished, and again the bell was heard from underground. This third time, the priest, the shepherd, and all the townsfolk understood—this crucifix was to stay in Chimayo.

The villagers built a chapel on the site of the discovery, and the crucifix graces its altar. The hole from which the crucifix was "resurrected" is the site of the holy soil for which the chapel is now also famous. *El posito*, the sacred sand pit, contains blessed or sanctified soil that offers healing.

People travel from all over the world to gather a small cup, a spoonful, a fistful of this soil to carry home with them. They leave prayers, letters, crutches, and braces, signs of need and signs of relief.

What's a lowrider? It is a remarkable car, beautiful and fascinating. It is an automobile that can have hydraulic lifts at each wheel, so the car can be raised or lowered, making it appear to be dancing. Often the cars have customized paint jobs—they come in a kaleidoscope of colors, textures, and scenes, beckoning for closer inspection. The interiors are usually elaborately detailed, with lush carpets and upholstery; often the glass is etched with designs, names, or religious motifs. The steering wheels are sometimes tiny, perhaps made of chain links, like a little circle.

Lowriders are ideal for Saturday night courting or Sunday morning church going. On main streets all over New Mexico they come out to parade up and down the drag. It's like the old courting scene from a hundred years ago, when boys would walk one way around the church square and girls the other way, and they'd eye each other as they met, going around and around. The older folks would sit on the sidelines and gossip and remember.

Today's courting is wilder. A group of young men in one car and a group of young women in another might drive around, yelling at each other at stop signs, stopping in vacant lots to trade rides, jokes, and kisses. But often, older, married couples parade their cars, too, filled with family members, on Saturday nights or heading to church on Sunday morning. You can see the older ones eyeing the younger ones—"We used to be like you, free and irresponsible. Learn a lesson from us." Many low-rider clubs work to raise community consciousness with their cars. They might collect toys for charity or money for medical needs or promote anti-alcohol and anti-drug programs.

The beauty of a lowrider lies in its design and in the love lavished on it by its owners. Just as old cowboys loved their horses, these men and women love their lowriders. The meticulous care and attention to detail they devote to these cars is almost religious. And if the car is representative of faith—as the car *Chimayo* is—then God must indeed be in the details.

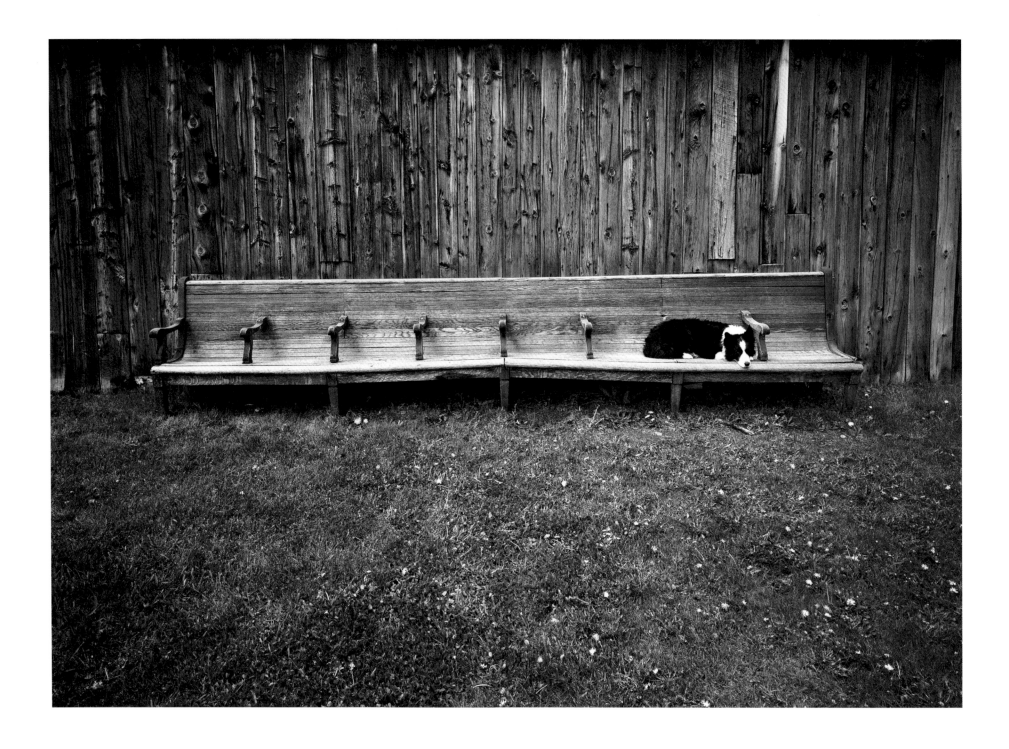

KALI ON RAILROAD BENCH
VIRGINIA CITY, MONTANA, 1999

CRAIG VARJABEDIAN

FOR MANY YEARS I'VE TRAVELED AND PHOTOGRAPHED with my good friend Paul Cousins. He's an intriguing man. He's not compartmentalized, like a rolltop desk. He's more awash with ideas that constantly flow into each other, like a stream. When we're out in the field together and the spirit moves him, he can pull meaning out of all kinds of things, not to lecture but to share, because he's moved by the place or image or event.

I'm very taken with his dedication and his ability. He never shies away from hard work. His wife, Doris, tells the story that when Paul was in theology school, when they were first married, he'd go to school by day, work at a grocery store at night, and bring home empty cardboard boxes to heat the house. They sometimes lived on food from dented cans that couldn't be put on the shelves or cans that had lost their labels. They'd line the mystery cans up at night, shake them, guess what they were, and then open them and eat whatever fortune had provided.

We met when I was first teaching at Ghost Ranch. Paul attended one of my early workshops, "Photography,

Spirituality, and the Land." He'd been to a Ghost Ranch retreat before, as a Presbyterian minister (he's since retired). This time he was interested in the theme of the workshop and in improving his photography. He is mainly self-taught. He had a son-in-law who gave him a fine old baby Deardorff view camera, and he showed up with that, which immediately created an affinity between us, since I use a large-format view camera, too.

Paul was affable and had lots of questions. After the workshop ended, we stayed in touch. At one point he asked me, "If I carry your camera gear, can I follow you around and watch you photograph?" I chuckled, but the idea lingered. People often ask to accompany me on my photographic journeys, but Paul wanted to give something back—he was willing to help. That really endeared him to me.

After we got to know each other better, he invited me to come photograph at one of his favorite places—the Grand Tetons. He has explored those mountains and trails for over thirty years. For him to share that with me felt like a huge gift. One fall, he and Doris came down in their trailer and I joined them in Jackson Hole. Doris cooked for us and took it easy while Paul and I wandered all over, making many

photographs. Back then, I carried all my camera gear in something like a suitcase, and Paul introduced me to the camera backpack, for which I am eternally grateful.

I'm also grateful for his friendship and all our adventures together. The Tetons are just one of many places where we've gone to photograph and explore. We have made pictures together in Montana, California, Arizona, and New Mexico. I wonder sometimes whether we spend more time laughing together over the day's events than photographing. We've actually had people pound on our motel door at the end of a day, telling us to quiet down. My life is the better for knowing him.

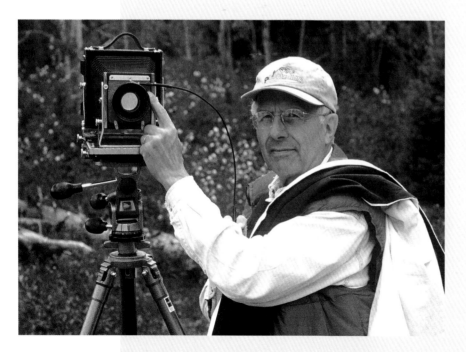

Paul Cousins with his baby Deardorff view camera
near Jackson Hole, Wyoming.

We've made many good photographs together, and Paul was with me when I took many of the photographs in this book. It's fitting for him to tell in his own words this story about Kali, his family's dog.

PAUL COUSINS

Craig and I had been photographing the Masonic Lodge and schoolhouse in Bannack, Montana. Bannack was the first big mining town in the state. The second one, and the one that became the capital after Bannack, was Virginia City, which was where we were for this photograph. If you want to know some of the history of Montana, just read about the mining towns: Bannack, Helena, Lost Chance Gulch.

Virginia City was owned by a family at one time, but the state purchased it and is now trying to restore it. It's not really a ghost town—people actually live there. But it's a bit out of the way. The highway does goes through town, but first it goes up to the mountains and through a pass on the east and down a valley on the west. You have to want to head this way.

Craig and I had been exploring the town. Outside of an old building we saw this wonderful bench. It's an old train station bench, pretty weathered and worn, but still elegant and worn smooth with time and the heft and slide of waiting people sitting upon it. Craig said, "Look at the texture of the wood. I like that. Hmm. Look at the bench. Look at the grass."

Craig started right to work, setting up his gear, looking at the bench, thinking about it, making photographs, and I thought, "This may take some time, I'm going to let the dog out of the truck." I wandered off and came back with Kali, my son's dog.

Now, Kali is obsessed with sticks. Certifiably obsessed. She grabbed the first stick she saw and carried it over to where Craig was. Well, he was

busy. That was no good. So she jumped up on the bench and sat there, eyeing me.

Craig had been about finished and was going to pack up so that I could set up my tripod and make some photographs. But when Kali jumped up on the bench, you could tell he saw this as an incredible moment. He jerked his head at me imploringly and I knew to go stand there and keep Kali's attention.

You can see that Kali went straight for the best place on the bench, where one of the arms is missing, so she has a nice wide place to lie down. She can lean her head against another arm if she wants, and she can hang her nose over the edge.

Right below her, on the ground, is the stick. What happened that afternoon is that she looked at me, then the stick, me, then the stick, never moving her head, only her eyes. As long as I stood there, with my hand up, my finger pointed to her, she waited. And this is the tricky part, because it was an overcast day, and Craig's camera exposure was easily four to six seconds long. But she didn't move during those seconds. And you can see her eyes, if you use a magnifying glass—they are so sharp. She didn't move or flinch as animals often do when they hear the sound of the camera's shutter.

Kali is a border collie, and border collies are independent. They have high energy and pretty quick minds. They can be intense, but they make great pets. Kali tends our family, watching over us wherever we go. She is also good at obeying commands, which is proved by this photograph. This was her gift to Craig because she wouldn't hold still for another one. You could hear her thinking, "Nonsense, I've got a stick to chase."

Later on, Craig, being the careful gentleman he is, wrote to me and my son, Kurt, for permission to use Kali's photograph. Of course it was OK with us, but as always, Kali got the last word.

To WHom It May Concern: I, Kali, do hereby make it known that I, Kali, am NOT owned by anyone. The opposite is true. When you enter my territory you will act in accordance with my rules.

Duly signed in the presence of witnesses. Kali, of 'on Hope Road' going out of the town of Philipsburg.
Please come see me. You will find all the above to be true.

When you photograph a person, a place, or even someone's pet, with the intention of publishing the image, you should always get a model release. This is the one I received, duly signed by Kali.

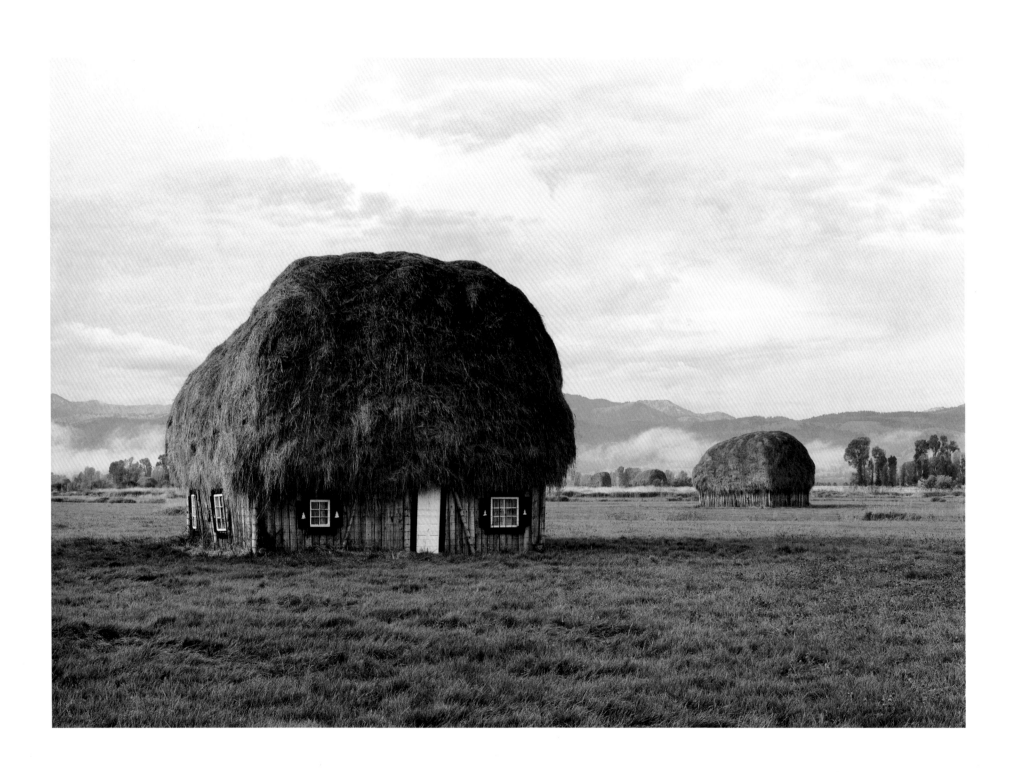

HAYLOAVES ("AFFORDABLE HOUSING") JACKSON, WYOMING, 1998

CRAIG VARJABEDIAN

THIS IMAGE TAKES ME BACK TO THE AGRICULTURAL BEGINNINGS of the West, when most people worked outside, knew the value of hard labor, and had something to show for it at the end of the day or season. Farmers grow and cut hay every year as part of a cycle to feed livestock. It may be a chore, but they store it with imagination and flourish. It's such a sight to see the stacks and stacks of hay in the fields and the big trucks going by with their sweet-smelling bales, still green and fresh.

I suppose that as a photographer I like the idea that I, too, will have something to show at the end of a day—a photograph that captures the day or the essence of a moment. And this photograph was unusual. When I saw this hayloaf I thought, "Well, that's different. You don't see that every day." Hay is rarely stacked anymore; it takes a special piece of equipment called a beaver slide to do it, and it takes a bit more time and effort. Most people today simply use a bailing machine that scoops the hay into big rectangular bales, fragrant in their own right but not as exciting or fun.

I look at these hayloaves and see a time that's almost gone. The ranches and farms of the West still exist, but their importance as mainstays of the community and its business life has dwindled. Fields have gone fallow, herds have been sold off, new enterprises such as bed-and-breakfasts

47

November 23, 1998

Dear Craig,

Now that the snow has hit the ground I will try to sit still long enough to catch up with some overdue letters. I hate to see this great fall come to an end but there is no point in denying the fact that it is time for winter. I imagine we get winter before you and ours lasts quite a bit longer, something you should be aware of since you are planning a trip to Wyoming in May. There are two ugly months, April and parts of May. May can be muddy and gray but does look a bit greener by the end of the month. The ranch looks pretty beat up and you are right, the haystacks are fed out, most of them anyway. The thatched roof stack will not be fed out so if you are only interested in that one it will be there, unless we have a tough winter and have to feed a lot of hay. I think the only nice things to look at here in May are the calves. You are welcome to come and take pictures if you want. We do a big cattle drive on the 15th, or near that time, and we do brand the calves the first week of May if you are at all interested in that kind of stuff.

Jackson has a tough time providing affordable housing for a lot of people. Quite a number of wealthy people have moved here and the price of land and homes is pretty steep. A lot of the service people have a hard time making it here so many drive over Teton Pass or through Snake River Canyon to come to work every day. A group of us on the ranch decided to turn one of the stacks into an "affordable house" and that is the story behind the one with the windows and doors.

I just wanted to mention that if you do plan on coming here and wish to meet a few people I sure can gather a group of photographers that would really be interested in meeting with you. I was showing a few people your book and they would really enjoy meeting you. If this sounds at all interesting just drop me a note. I look forward to seeing one of your photos of the ranch.

Sincerely,

Liz Lockhart

While photographing, I often meet kind and generous
people. Ranch owner Liz Lockhart let us photograph
the haystacks in her fields and invited us back
to photograph a cattle drive the following spring.

and dude ranches have replaced the working of the land. I know things change as time passes, but I will miss the grand haystacks and beaver slides. I'm glad to have found these examples to photograph.

I almost didn't. I was traveling with my friend Paul Cousins, looking for places that spoke to us to photograph. Paul was driving and I was looking straight ahead when a voice in my head said, "Look to the left." Otherwise we might have driven right by these haystacks.

We were up on a hill. Looking down, we could see about a dozen hayloaves in a field. We had been in some pretty untamed landscapes earlier: mountains, forests, rivers. But here was a wide open, cultivated field. The hayloaves in it stood about twelve feet high. One of them was decorated to look like a house. It looked so real that at first I actually thought people were living in it. For a house, it would have been small and quaint, like a little Irish cottage. I felt as if I were in that mythical place Brigadoon and wondered if the house had been there for a hundred years or more.

We drove up the road to the ranch house to ask permission to make photographs, and the woman of the ranch, Liz Lockhart, who was not dressed in Irish garb at all but in jeans and denim shirt, granted us permission.

We wandered around and made a few pictures that day, but we knew we would come back the next morning to make more. Previous mornings when we had been up early, there had been an ethereal and magical mist in the air, and we hoped it would appear on this field.

We hurried back early the next morning. The field was indeed shrouded in mist. Hayloaves appeared and vanished as the fog flowed around and over them. We carried our camera gear to the field. The grass was wet with dew and mist. Soon, so were we—soaked to the knees, squishing along, lugging our gear, climbing the fence. Once in the field, we started to explore for the best site to set up in.

To find the best place from which to photograph, I use a small, portable viewing frame (in my case, cut to the proportions of the camera's

format) to compose an image. I took my viewing frame, walked around, and figured out where the elements needed to be. This picture just fell into place. Then we set up our tripods and cameras and started working. The sun eventually burned off the mist, but we made several good photographs, including this one.

Later, I sent a copy of the image to Liz with a note asking if she could explain the hayloaf that looked like a house. This is what she wrote in response: "Jackson has a tough time providing affordable housing for a lot of people. Quite a number of wealthy people have moved here and the price of land and homes is pretty steep. A lot of the service people have a hard time making it here, so many drive over Teton Pass or through Snake River Canyon to come to work every day. A group of us on the ranch decided to turn one the stacks into an 'affordable house,' and that is the story behind the one with the windows and doors."

One of the most basic decisions that a photographer needs to make is where the edges of the photograph are. A viewing frame is an invaluable tool to help facilitate that decision.

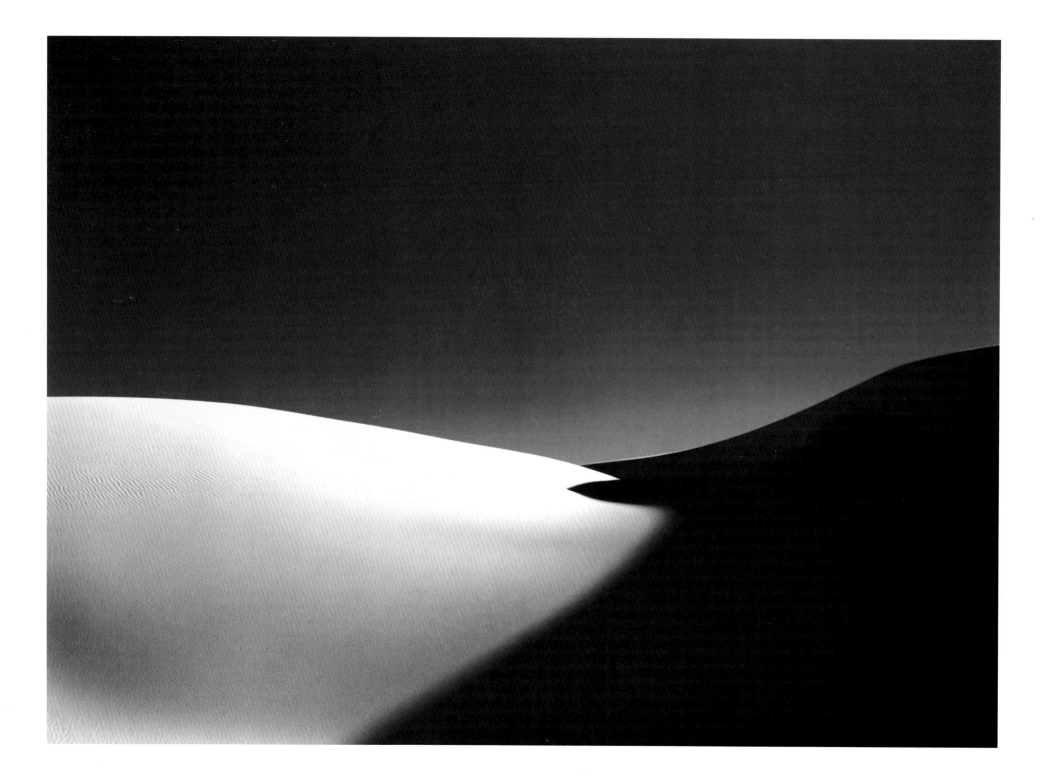

To me the desert is stimulating, exciting, exacting; I feel no temptation to sleep or to relax in occult dreams but rather an opposite effect which sharpens and heightens vision, touch, hearing, taste, and smell. Each stone, each plant, each grain of sand exists in and for itself with a clarity that is undimmed by any suggestion of a different realm. *Claritas, integritas, veritas.* Only the sunlight holds things together. Noon is the crucial hour: the desert reveals itself nakedly and cruelly, with no meaning but its own existence.

—Edward Abbey, *Desert Solitaire*

ROBIN JONES

THE SEA IS COUSIN TO THE VAST DUNES OF NEW Mexico's White Sands National Monument. The sparkling white expanse, like the sea, is constantly moving: shimmering waves beckoning to distant horizons. The same words can be used to describe the sea and the dunes; the same thoughts of distance, travel, and change gather in the mind as one stares at the breaking waves of the ocean or stands on the outskirts of White Sands, the glittering gypsum moving away in dunes and ripples.

There are four types of dunes: dome, barchan, transverse, and parabolic. Dome dunes are low mounds of sand, and barchan dunes are crescent shaped. Transverse dunes are created when barchan dunes join, forming ridges of sand. Parabolic dunes hold plants, which alter the crescent shapes of barchan dunes, inverting them into parabolas. Ocean waves, too, are called by different names: capillary waves, chops, swells, tsunamis, seiches. The shapes are not simply curves or swells—in desert and sea, dunes and waves are products of pressure, wind, gravity, and friction.

Ringed by mountains, White Sands National Monument lies in the Tularosa basin between Alamogordo and Las Cruces in southern New Mexico. It is desert now, but once it was ocean. During the Permian period, 250 million years ago, part of New Mexico was covered by a sea. Its marine deposits reappeared as gypsum (calcium sulfate) about 70 million years ago, when the sea dried up. The Laramide uplift, the compression that formed the Rocky Mountains, moved the gypsum deposit to the tops of mountains. Then, perhaps 30 million years ago, the mountain range shifted and the crust subsided and fell, leaving two ranges—known now as the San Andreas and the Sacramento Mountains—framing a basin.

Gypsum trickled down to the basin floor, and runoff formed a lake there. Later the climate grew arid and the water in the lake evaporated, leaving crystallized gypsum trapped in the shallow bowl of the land. The mineral deposits formed an ocean of crystals—selenite—breaking down, building up, accumulating into forms that shifted and swayed, surged and eroded.

The dunes have been forming for perhaps sixteen thousand years. In geological time, they are young. They are constantly moving, slowly perhaps, but driven by wind and the pressure of grain against grain.

Footsteps disappear quickly in the dunes as the wind resurfaces the sand. But people have long walked through this land. The Mescalero Apaches lived here for many years until they were supplanted by Spaniards who founded La Luz, a village adorned with white—gypsum from the dunes smoothed onto adobe walls. After the Spaniards came Euramerican homesteaders, the railroad, cattlemen such as John Chisum, and outlaws such as Billy the Kid. The white sands drew all sorts of people to their shimmering shores—perhaps a mirage of opportunity, potentially a land of riches. The dunes themselves, it could be seen, might someday be at risk if industry and development continued.

White Sands was made a national monument, and thus protected, in 1933. That does not mean the land is pristine, isolated from human activity, although photographs might lead one to imagine that it is. Instead, the dunes have long been the center of dramas and arguments over conservation, Native rights, recreation, agriculture, cattle ranching, mining, and tourism. White Sands National Monument is a model effort by the National Park Service to mesh the preservation of a natural wonder with cultural, political, and military needs and with the public's desire for museums, visitor centers, and roads. Despite new and improved roads and highways, this is still not an easy place to get to. Sometimes the road to the monument, Highway 70, is closed. At those times one can hear the distant sound of armaments or the test firing of missiles. The Alamogordo Army Air Base was established almost immediately after

Pearl Harbor. The U.S. Army had asked for land in order to test weapons and practice troop movements and eventually to use as a bombing range. Parts of the Tularosa basin ranchland were accordingly appropriated. The world's first atomic bomb was exploded here, at the Trinity Site, in 1945.

Throughout all this history and all these encroachments, the dunes have gone on shifting in the wind. Sometimes vegetation holds the sand at bay, but the yuccas, saltbushes, and grasses more often adorn the landscape than control it. Animals live here, many of them having assumed a whitish color adapted to this sparkling environment: mice, White Sands prairie lizards, and the bleached earless lizard. The gypsum sands remain steadfast in their endless change, beautiful in the naked, sense-sharpening way that Edward Abbey described. White Sands is *claritas, integritas, veritas.*

CRAIG VARJABEDIAN

The "white sand" of White Sands is not sand; it's actually gypsum. It is eggshell white or pinkish, not true white. But in black and white it photographs beautifully—the texture of the sand and the contrast between the light and the land. The best times of day to photograph it are early morning and late afternoon, when the sun is low on the horizon and shadows define the landscape. The best time of year to go there is between October and February, when the weather is kind. In the spring, the winds can be fierce, kicking sand into your eyes and your camera. Summer can be brutally hot.

When you walk into the desert at White Sands, it's easy to lose your way. A tourist was once lost there and actually died. The day I made this photograph, Cindy Lane and I got lost, too.

We had hiked out westward, but there are no trails to follow—you just

go over dune after dune. We were completely absorbed in the wonder of the place. I'd see some marvelous configuration in the sand and run over to photograph it. Then I'd circle around it, looking for new images to make. I forgot which direction we had come from.

Eventually, we noticed we were lost. There were no visual cues to lead us back, no recognizable landmarks to ground us in saying, "Ah, that's where we should turn left." I didn't let on for a while, because I didn't want to make Cindy nervous—or admit that I was. (Later, I got a hand-held GPS device to mark the trail "electronically" when I was hiking.)

But feeling lost is what helped me find this picture. Not knowing where I was, I simply followed light and shadow. My awareness became keenly attuned: I was fully present in the desert, under the sun, walking over the sand, gazing at the glittering horizon. And then I saw where I was. I was in a luminous white bowl within the dunes, with a blue canopy of sky over me. In front of me a shadow was moving down one side of a dune to embrace the light arcing out to meet it. The sky seemed to join light and shadow together, a duality of yin and yang. I was in the truth of a moment—a moment of being completely present, because there was no other place I could be, no other way for this place to be.

I made a photograph. I felt a release, a gasping awareness of where I was, no longer clueless, helpless, frightened, and anxious. As the song "Amazing Grace" puts it, "I once was lost but now I'm found"—I felt an awareness so complete that I would describe it as profound clarity. I was in the world, in the midst of a truth that, even as it changed with the wind, would always be there.

We did find our way back. We were lucky. After making this photograph, I climbed the highest dune nearby and surveyed the landscape. Just on the other side of that dune was our truck.

An interesting thing about this photograph is what some people see when they view it. I'm sometimes asked, "Who was the model?" They see an unclothed figure of a man or woman.

Georgia O'Keeffe denied people's observations that her flower paintings were renderings of sexuality. To her, they were flowers. Her vision and aesthetic defined the way they were painted. I didn't originally see a figure in my photograph—if anything, what I saw is a yin-yang duality: light and dark, smooth and rough, male and female. In other words, I see a wholeness and a tension in the image that I like. But I can now see the human figure after people have pointed it out to me.

I don't want to deny what some people see in this photograph. Good art should invite participation; people should find their own responses. If the artist tells you everything, gives you all the clues to the work, then there is no invitation to look further. Viewers need to find their own way into an image. If I leave obvious footprints for them to follow, they won't have the opportunity to lose their way and find themselves again.

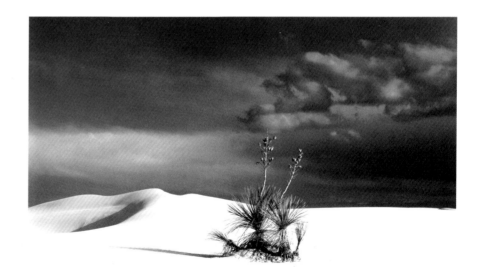

One of my most popular photographs has been of these yucca plants at White Sands. The yucca is the state flower of New Mexico. (*Yucca, White Sands National Monument, Alamogordo, New Mexico, 2000.*)

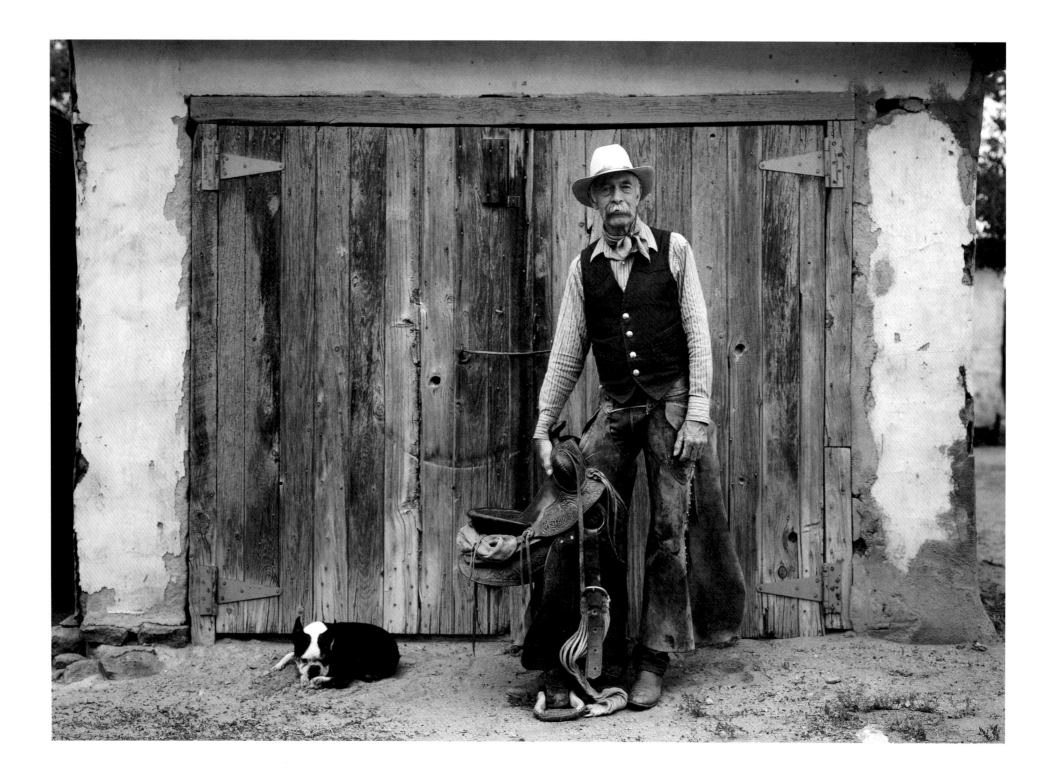

ARCHIE WEST AND BUDDY
SAN MARCOS, NEW MEXICO, 2001

CRAIG VARJABEDIAN

I HAVE MADE MANY PORTRAITS WHOSE PURPOSE WAS TO MAKE THE subject, or client, appealing and attractive and satisfied with the way he or she looked. There is a big difference between the commercial portraits I used to make and the portraits I now make for myself. Perhaps that makes me a harder critic of my work, but it also frees me to be creative and authentic.

That said, I hadn't at first considered myself a photographer who made revealing and insightful photographs of people—images in which something meaningful about the subject was revealed. I saw myself as a photographer of the natural scene. But I'm aware of what makes a compelling portrait. One of my favorite portraits is of Winston Churchill, a photograph made by Yousuf Karsh in 1941. Churchill was posing, smoking as usual, and Karsh snatched the cigar out of his fingers. Churchill glowered at him, Karsh released the shutter, and the rest is history. And that's what makes the portrait authentic—seeing the defiance, the sheer force of the man come through in the image.

A good portrait reveals something deeper about the person in front of the camera. It's not just a record of what someone looked like, as in a passport photograph. It's the essential or poetic element of a person—that quintessential aspect that we remember, laugh about, cry about, love, or

This photograph of Archie and me was made by Ira Gostin
about a year before I made my portrait *Archie West and Buddy.*

(Photograph by Ira Gostin / gostin productions.com.)

even fear. I call this "poetic identification," because poetry is supposed to
be just that, the essence of what the writer wants you to feel. Those are
the photographs I like and the ones I strive to make.

Henri Cartier-Bresson, in his book *The Mind's Eye: Writing on Photography
and Photographers,* noted the difficulty of portrait photography: "If in mak-
ing a portrait, you hope to grasp the interior silence of a willing victim,
it's very difficult, but you must somehow position the camera between his
shirt and his skin."

One of my "willing victims" is my friend Archie West. I know of no
man more comfortable in his own skin (or shirt) than Archie. He is a tall,
lanky cowboy in work jeans and boots, with a neckerchief snugged up to
his neck and a tousle of gray hair under his hat (which he always takes off
to greet people). His face is lined from sun and hard work, but the light
in his eyes dances.

Speaking of dancing, nobody dances better than Archie. He is a main-
stay at the Santa Fe hotel La Fonda and other two-step hangouts. Many
people in town know Archie because he dances; mention his name and
you'll usually get, "Oh, I've danced with him," or "He's a good dancer."
I love to hear Archie sing. He'll sit on the porch on a warm summer
evening, strumming the guitar and crooning "Goodnight, Irene." I can
imagine him humming and singing in the saddle, soothing the cattle and
keeping himself entertained with all sorts of songs. He's a real cowboy.

Archie has been a willing and generous model for my photography
classes at the New Mexico Photography Field School. Cindy Lane, my
photographic assistant, and I met him years ago at the home of a mutual
friend, the historian Marc Simmons. It was New Year's Eve, and Cindy
and I had stopped by after photographing on Marc's ranch. We were on
the front porch talking when an old pickup drove up and a cowboy got
out, waved to Marc, and nodded at us. Introductions all around, and then
Marc and Archie started talking. Archie keeps some horses on Marc's
property and wanted to discuss where fences needed to be mended.

When they were finished, Archie tipped his hat and headed out for a New Year's Eve dance.

We spent the rest of the evening drinking champagne and hearing Archie West stories from Marc. We heard about how he and Archie had met Jack Schaeffer, the author of *Shane*, and how Archie was the model for Schaeffer's book *Monty Walsh*. We heard about Archie's dancing, about his upbringing as the son of the artist Hal West, about his movie career, and about how he had replaced the leathers and oiled the gear box of Marc's windmill. The kerosene lamp was glowing; we could just make out Marc's smile as he talked and painted a picture of his long-time friend.

We couldn't wait to see Archie again and get to know him better. Several weeks later we went to talk to him, to see if he'd be willing to model for our photography workshops. He agreed. He was amused and warned us, "I'll break your camera!" but he was perfectly at ease in front of it. He wasn't nervous; he was simply patient and good-natured.

ARCHIE WEST

My dad, Hal West, was from Oklahoma. He was an artist. My mother came from Ohio. We ended up here in New Mexico. That's where I was born and have lived ever since, except for two years when I was in the army, in Georgia.

When I got out of the army, I knew I didn't want any kind of job where I'd have to work from eight to five and wear a uniform or a suit. We'd had livestock at home, and I was familiar with milk cows and horses. So I took my saved-up army pay and bought some heifers, just a small bunch, and set off from there.

When I was a cowman, I was on horseback a lot. I suppose that's one reason to have cows, so you could stay out away from things and be on a horse. And that's what I did, tracking cattle down because everything wasn't as fenced up back then. There was more range and fewer fences, and you had to keep watch on them. You had to brand the calves, feed them, take care of them, gather them up, and sell them.

I stayed on the family homestead, by San Marcos. I live in the same house I grew up in. I have eighty acres, a good piece nowadays. Some of my neighbors go off to work in the morning, away from their two-acre bits, and I'm happy out here in the middle of my eighty acres. Of course, when I grew up here there was nothing around between here and Santa Fe. That's happened in just the last twenty years or so. My son lives next door to me now, with his wife and their little baby. I stay home more nowadays, to mind my granddaughter, to help out.

I got offered roles in some movies—westerns, of course. They were fun to make. You see *The Cheyenne Social Club*—I shot a scene there with Henry Fonda, branding calves. But after working in a couple more movies, I decided it wasn't for me. I'm too busy. I've been married, had kids, sent them to college.

Getting married is real easy. It used to be as simple as making adobe bricks. You'd figure out you wanted to get married, make some adobes, build a little house, and move in. That's what my son did, built this little adobe house next to mine. Of course, staying married is not so easy. But getting married isn't hard at all. Just make a few adobe bricks.

CRAIG VARJABEDIAN

This photograph was made at Archie's place south of Santa Fe. For this portrait session, I had scouted the location in advance. We went to Archie's place and he walked around with Cindy and me as we looked for potential places to photograph him. When he paused in front of this door, I knew we had found the right place. The beautiful old doors

This is the Aermotor windmill that
Archie West serviced for Marc Simmons.

(*Aermotor Windmill, Garden of the Gods, New Mexico, 2002.*)

complemented Archie. There was a synergy between the subject and the background—rugged meeting rugged. I liked the way the texture of the door matched the texture of the man.

I was teaching a workshop on portraiture called "Ranchers, Ramblers, and Renegades" (from the title of one of Marc Simmons's books). I was taking the students through a portrait session, from start to finish, from setting up the camera and positioning the subject to developing a relationship with the subject. You can't just stand there and hope the subject will open up to you. You have to engage with him or her. I had set up my own camera, just to show students how I do it. I rarely photograph for myself when I'm teaching—I'm too engaged with my students and what they're doing. And if I am photographing, I'm too engaged with my subject to connect with anyone else.

We tried different poses, the saddle higher, lower, on the ground, Archie looking straight ahead, to the left or to the right. He had been stoically posing, gazing at us with those sharp eyes, so ready to catch sight of stray cattle or a pretty woman who wanted to dance. When the students were through photographing Archie, they wandered off to explore and to make more photographs around Archie's compound. I had been enjoying myself and thought I would make a couple of exposures of Archie, too. My gear was still there and the camera was focused.

Just as I was preparing to photograph Archie, the dog Buddy wandered into the scene. I've talked about recognizing the precise moment, and this was it. Buddy sat down, then lay down and started to chew on his leg. Archie looked down at him with the kind of amused look any cowboy would give a little "dude" dog. I said, "Archie, look at me," and he shifted his gaze to me. He had no time to react to anything, to me, to my request; he didn't even have time to make a joke—he was still in that moment of being with Buddy. I made the picture.

I had no time to take a light-meter reading; I just had to figure out the exposure in my head. One of the things I've worked hard at as a

photographer is to train my eyes and brain to act as a light meter in order to make exposure calculations. If my light meter should die in the field, I'll still be able to come quite close to a correct exposure. Or if something happens so quickly that I don't have time to use the light meter, I won't miss a great moment. If time permits when making a picture, I'll look at the scene, figure out the exposure, and then check the light meter to see how close I am to proper exposure. Students sometimes marvel at this, but it is something one can practice. I believe what Louis Pasteur said: "Chance favors the prepared mind." I've prepared for years for moments like this—moments when I have no time to meter the light in a scene.

Thirty seconds later, Buddy got up and tripped off, after his own business.

When this moment happened, it created an appealing and perfect image. There is Archie, an authentic cowboy, and there is Buddy, a little Boston terrier who belonged to Archie's daughter-in-law (Buddy died in 2005 and is much missed) and who can be described only as a city dog. He certainly doesn't look able to bring in a herd. It's unexpected that these two would have been friends. It's a contradiction, but that's the way it was. Perhaps what this photograph really demonstrates is their similarities—they are two independent cusses, both "the real thing."

I was afraid we had worn Archie out with so much posing that day. But it turned out later that no, he went into his house, got dressed up, and went out dancing at La Fonda.

In simplest terms, a spotmeter measures light in very small areas of the scene. Sometimes I use one, sometimes I don't.

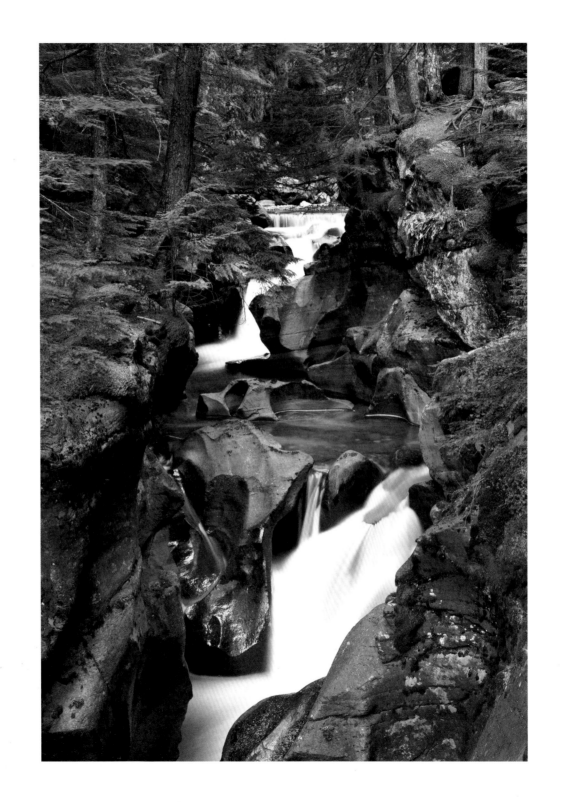

AVALANCHE CREEK WATERFALL
GLACIER NATIONAL PARK, MONTANA, SEPTEMBER 11, 2001

CRAIG VARJABEDIAN

THIS IS, I THINK, A BEAUTIFUL PHOTOGRAPH, BUT THE DAY I TOOK it was of one of the most horrible and tragic in United States history—September 11, 2001, the day of the terrorist attacks on the World Trade Center and the Pentagon. I will never make sense of that event. Every time I look at this image I think about that day and how no one old enough to remember it will ever forget where they were on that awful morning.

My friend Paul Cousins and I were in Glacier National Park in Montana. Paul had been telling me about this magical place along Avalanche Creek for several years, and I knew I wanted to make a photograph of the waterfall in the soft light of early morning. We set out at first light from our little motel, but there was no real sun—the sky was overcast and everything seemed softened. We got to the park about 6:00 A.M. and headed up the trail. I was hiking with a fifty-pound pack and feeling every pound of it. Paul kept saying, "It's just ten more minutes," but as is always the case on hikes, it turned out to be another half hour. But when we got there, it was a beautiful view and I did want to make a picture of it. So I looked around and thought and measured. I planted my tripod about fifteen to twenty feet off the trail and got to work.

When I made my photograph of the waterfall,
I had to place the camera precariously at the edge of
a sheer precipice and wait for the soft light of dawn.

I hadn't had my coffee and I was muttering under my breath when we heard footsteps. We looked up to see a park ranger on the trail. He spoke to us: "Have you heard about the airplanes that crashed into the World Trade Center?"

Six in the morning in Montana is 8:00 in New York, so it must have been about 7:30 or 8:00 Mountain time when we heard the news. The plane had just crashed into the Pentagon as well. I don't know how the ranger knew about it or why he was on the trail; maybe he needed to get away from the horror of it.

I remember thinking, "This is terrorism," and worrying about my family, even though none of them was in New York or Washington. But I knew that friends and acquaintances might be suffering.

Paul said, "Go ahead and photograph the waterfall." He didn't dismiss the events or our feelings about them; he just reminded me to do my work. At the moment that was to record the beauty around us, even as our brains were beginning to conceive of the pain and chaos that must be gripping the nation.

So I made this photograph. I made a deliberate decision to leave the shutter open for about eight seconds, so the water appears as if it is a veil flowing down the rocks. If I had kept the shutter open for a shorter time, the water would have appeared frozen, giving it a glassy effect. I wanted it to have a sense of movement. At one time I had done a series of tests of moving water at various exposure times to determine how I wanted to render it in my photographs. So I knew how long I wanted to expose this scene.

Other photographers have made pictures of water that is rendered softly—William Henry Jackson comes to mind. He had no choice. The photographic emulsions of his day, the early 1870s, were extremely slow and required long exposures. Many older photographs render water this way. I like that. I like it that my work sometimes harks back to another time, even though I use today's modern films.

Paul and I went back down the trail and drove to park headquarters at Apgar. The managers at the hotel there had taken televisions out of the rooms and set them up on picnic tables, and every channel was tuned to the East Coast. People were clustered around the tables, watching. As I stood there and looked at the line of television sets, I could see multiple images of the airplane crashing into the World Trade Center.

We heard that airports across the country had been shut down. Travelers were stranded and businesses closed. We couldn't tell which newscast to believe; there seemed to be no real clarity. Paul and I headed for the phones. It took a while, but by afternoon we had spoken with all our family members and knew that our immediate circles were safe.

Paul and I had a truck—we weren't dependent on the airlines—so we discussed what we should do. Go home? Stay and continue photographing in the park?

Thinking back, I feel now that our decision—to stay and photograph—was influenced by that pristine moment at the waterfall. Despite all that was going on, we were witness to a haven in the Montana wilderness. The water rushing down the rocks was a natural phenomenon, far removed from the horrible image of falling buildings. The waterfall was, to me, the stronger image, and I wanted to stay, in defiance of anyone who would try to keep me away from beauty. I could not, nor ever will, forsake my love and passion because others would deny or threaten me.

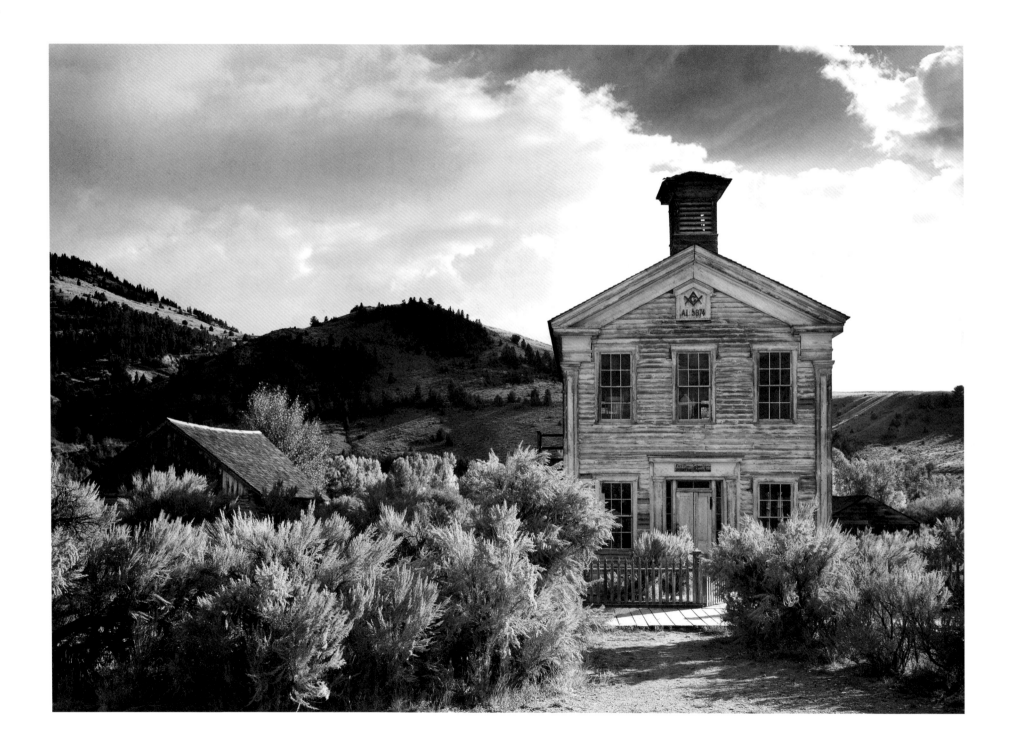

MASONIC LODGE AND SCHOOLHOUSE
BANNACK, MONTANA, 2001

ROBIN JONES

IN 1826, GOLD WAS DISCOVERED IN WHAT WAS TO become Bannack, Montana. With the gold came the miners, and with the miners came everyone else and a town: the Mead Hotel, the church, the judge's house, various stores, a bar, little mining shacks and shanties. Bannack got to be so big that it was named the first territorial capital of Montana.

As a capital, it needed a school. The school trustees met with the Masons, and the two groups collaborated to finance and build the school. The school got the ground floor, and the Masons, the second floor.

The town did well for a while, but then gold was discovered in Virginia City, about eighty miles away. People from all over the country headed there, and Virginia City, too, grew quickly. It replaced Bannack as territorial capital in the 1860s.

Nevertheless, Bannack stayed settled for quite some time. Although the town remained focused on mining, people experimented with other ways to make a living, and they kept the stores going. They went to school, to the lodge, to church. Some people still remember the Methodist church in

Bannack, where Brother Van used to preach. Brother Van, whose name was Van Arsdale, was an itinerate minister who would preach anywhere: schools, offices, saloons. People would know he was in town when they heard his strong voice booming out hymns.

Bannack shrank as time went by. More and more residents left for new dreams and opportunities. As in many other mining towns in the West, buildings were abandoned, the town dwindled to memories and echoes, and what was once the capital became a ghost town.

Nowadays, the Masonic Lodge and schoolhouse has a presence that reminds us of past activities. Despite its isolation, the building reverberates with the memories of school-children reciting their lessons, shuffling their feet, and, released, hollering as they run through the sagebrush. The second floor is spirited by men busy planning for the future of a town, clearing their throats, speaking, advising, arguing, and preparing to do good deeds.

In the photograph you can see the top of the staircase that leads up to the Masons' second-story headquarters. Through the middle window you might be able to just make out a chair with a curved and pointed top—a Mason's

chair. On the other side of the building, hidden by the chamisa bushes, is an old merry-go-round.

In the 1950s Bannack was made a state park, so the town is now well cared for. A ranger lives there and keeps an eye on things. Plenty of people visit, especially Masons, and once a year they meet there for a major assembly.

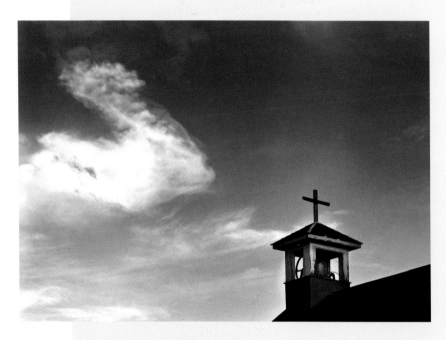

I feel that clouds often add a completeness to a photograph. The steeple by itself was beautiful and had a strong graphic look, but when the swan cloud appeared, the two objects shared a powerful harmony.

(*Cloud and Steeple, Vallecitos, New Mexico, 1997.*)

Although a lot of my photographs are landscapes or portraits, I also delight in making photographs of architecture, especially in the West. Buildings there, however small or large, humble or grand, have histories and stories that are often moving and amazing.

It was a clear day when Paul Cousins and I arrived at Bannack. I was hoping for clouds because, like the photographer Laura Gilpin, I don't like "naked skies." Clouds lend completeness to the image. But you still need the light to help describe what is being photographed.

Paul set off to make some of his own photographs, and I walked around the town for a while. When I came upon this building, I was captured by its presence. I began the process of photographing by walking around it with my viewing frame. It's a black card, about six by eight inches, with a rectangle proportional to my camera's frame cut out of the center. The viewing frame helps me determine where I should place the camera for making a photograph. My large-format camera is big and pretty unwieldy—I can't easily pick it up and rush twenty feet to the side to get another perspective—so I am very careful about preliminary visualization. I consider several different views in order to decide exactly where to stand. I also use the frame as a compositional device to figure out what to include (or not include) in the photograph. By moving the frame closer to or farther away from my eye, I can choose an appropriate lens.

I finally decided to put my camera on the tripod and put the tripod in the middle of the street. No one can drive on the roads; they are barricaded to preserve the town. The only traffic is the wind and tumbleweeds. I stood there in the road and waited for some time. While I had been looking for the photograph and framing it, some hoped-for clouds had arrived, but they had obliterated the sun.

Waiting is a big part of my photographic process. I am searching for a

kind of inner peace that quiets my expectations for a specific photographic result. What I am photographing is the essence of the subject revealing itself. When I make such a picture, I feel I've received a blessing, because it's not something I create, it's something I am given.

I waited a long time. Eventually the sun shone through the clouds. I knew I wanted a sense of the landscape as well as the building, but I felt the building needed to be dominant. So I waited for a time when the shadows darkened the surrounding hills. Just as that happened, a little sliver of sunlight struck the boardwalk in front. I made the photograph.

What I believe I have made, besides a wonderful photograph, is an image of commitment. The town's residents had joined together to express their commitment to their future by establishing this school. Masons had settled in the town, determined to uphold their ventures and covenants. That commitment lives, because the town is still there, maintained and protected. The Masons still come out and tend the building. While I was scouting out the place, I bumped into two of them: former state police officers who walked me around, told me stories, and shared a barbecue meal with Paul and me. There's even a website where F. Lee Graves, past grand historian for the Masons, tells of another act of commitment:

As is the custom on the front of every Mason Temple, there is a Square & Compass to announce that the Masons meet there, and the early Bannack Masons hastened to erect the universal emblem on the front of their building. They searched for a piece of hardwood from which to carve the ancient symbol, but after an exhaustive search the wood could not be found. Finally a hardwood bread board made of hickory from a comfortable home in the East was offered to the Masons by Mrs. Emily Drury Graeter, wife of the Beaverhead county pioneer, miner and active Mason, August F. Graeter. James S. Ferster, a Bannack carpenter and Mason who had come to the gold camp in 1863, carved the emblem.

My Ebony SV57UE Field View camera with a Carl Zeiss Protar Convertible lens on a Manfrotto 405 tripod head. This precision handcrafted camera is simply a bed that supports a moveable front standard that holds a lens and shutter, a moveable back standard that secures a holder loaded with film, and a bellows stretched between the front and back to keep the dark in. You focus the upside-down image by looking at the ground-glass under a dark cloth and moving either front standard (holding the lens), the back standard (holding the film), or both. The Carl Zeiss Protar lens is actually an assortment of matched lens cells that can be physically assembled in various combinations on the front and rear of a shutter to yield a variety of different focal lengths.

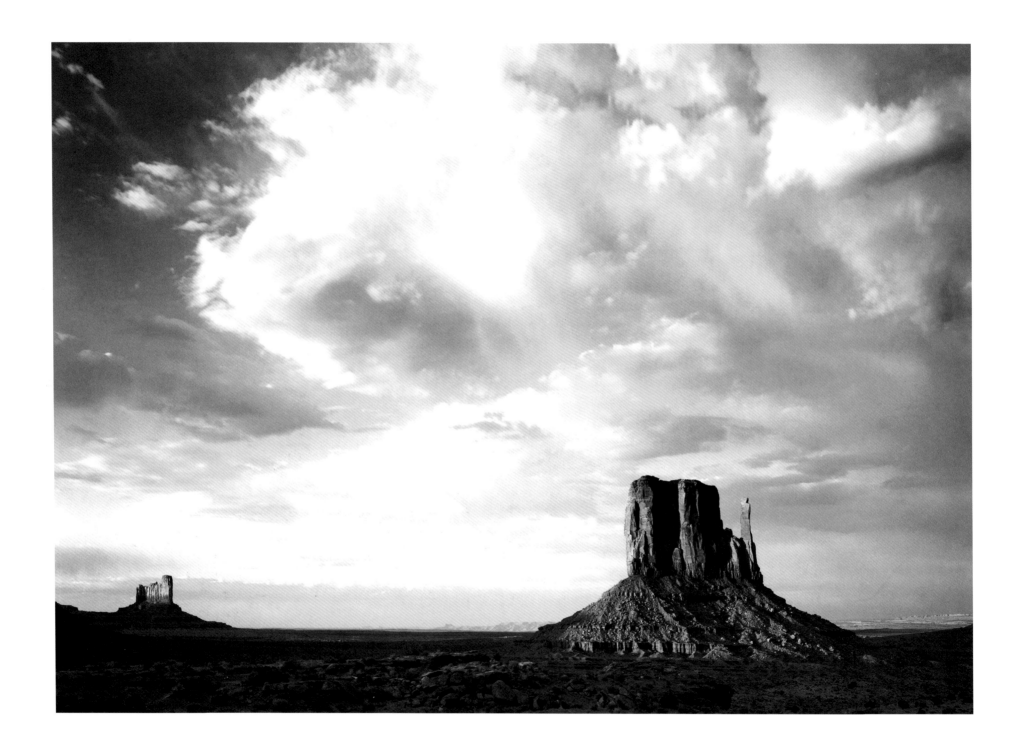

WEST MITTEN BUTTE
MONUMENT VALLEY, UTAH, 2003

You can say the real star of my Westerns has always been the land.
—Popularly attributed to John Ford, movie director

ROBIN JONES

PERHAPS JOHN FORD AND HARRY GOULDING ARE MOST responsible for having brought Monument Valley to national attention. Around 1921, Goulding and his wife, Leone (also known as Mike), bought a square mile of land in what was to become the Diné Nation. Many Diné refer to themselves as "the people"—Diné in their own language—rather than as the Spanish-implemented "Navajo." The Gouldings set up a trading post, scraping by like their Diné neighbors.

In 1937 Goulding heard that the movie director John Ford was looking for a location in Arizona to shoot a film. The story goes that he showed up in Ford's office with a bunch of photographs of the canyons, cliffs, and monoliths. When told that he had to make an appointment, he replied, "I can wait. I've lived among the Navajo so long that I don't get so busy that I can't wait." He unrolled his bedroll and settled down before the startled receptionist. She called Ford, and when he saw the photographs, he knew where to shoot his film.

The movie was *Stagecoach*, a western that made Monument Valley an iconic landscape for the Western frontier, blurring the lines between fact

Many people are familiar with the two Mittens at
Monument Valley from having seen them in many of
legendary filmmaker John Ford's westerns. This still is
from Ford's film *Stagecoach* that starred John Wayne.

(Photograph by Ned Scott. ©1978 Ned Scott Archive/MPTV.net.)

and fiction but also supplying much-needed income to the Diné, who were suffering through the Great Depression. Many of them worked on the set or were cast as extras—portraying Apaches, to their consternation and, one hopes, amusement.

John Ford made seven movies in Monument Valley: *Stagecoach*, *My Darling Clementine*, *Fort Apache*, *She Wore a Yellow Ribbon*, *The Searchers*, *Sergeant Rutledge*, and *Cheyenne Autumn*.

Other films were shot there, too; old movie sites are today a part of Monument Valley tours. Many Diné worked alongside Ford, John Wayne, Henry Fonda, Maureen O'Hara, Jeffrey Hunter, Woody Strode, and other old-time western stars. Relative newcomers such as Clint Eastwood, Peter Fonda, Michael J. Fox, and Tom Hanks have also joined the ranks of those filming under the lingering light and shadow of this vast landscape. Cast as Apaches, Cheyenne, or members of other tribes, and watching white men play Indian heroes, the Diné have sometimes enjoyed and sometimes resisted this cinematic remaking of history.

What calls these movie folk, the makers of myths, to Monument Valley? It could be the need to create something as lasting as the land. Throughout the various versions of "the West," of stories of cowboys and Indians, the only constant is the land. It cannot be remade. *Tsebii'nidzisgai* (the valley within the rocks) is the original. Movies and people are miniscule marks on its vivid red, gold, and blue horizon.

Perhaps the most striking and familiar features of Monument Valley are the East and West Mitten Buttes. These stark rock formations stand as sentinels, guarding the land of the Diné, the silence of the desert, and the splendor of the wilderness. Though men have tried to claim Monument Valley through names, fences, houses, and roads, the Mitten Buttes are untouched and untamable. They are the real stars, more impressive than myth, film, or man.

CRAIG VARJABEDIAN

When you go to Monument Valley, you don't go in and explore unless you have a Native American guide. The land belongs to the Diné. You may drive the seventeen-mile road, but you can't leave it unaccompanied. I went there with my friend Paul Cousins. We hired a Diné guide and asked him to show us the quintessential places in the valley. He was used to showing the landscape to photographers working in color, not to those working in black and white, so we were a bit new for him.

We spent the day getting a sense of the place and waiting for the light and the sky to work with us. It was warm and windy. We drove a bit, then hiked a bit, climbed up and looked around for places that spoke to us. We saw amazing and incredible landforms as the clouds swept past, the shapes and textures mesmerizing us. I made several photographs, some of which I thought were pretty good, but still something was missing.

When I photograph, I wait for a place to speak to me. I waited for this big valley to speak to me, for these spires of stone and visages of sky to reveal themselves to me. But I had come with many preconceptions about the area, inspired by movies and by other photographs. I had no relationship of my own to this place, and I needed to see it on its terms. I would have to lose my amazement and awe (which was difficult) and gain a more intimate knowledge of this land and light.

We spent two days exploring Monument Valley. Toward the end of the second day, I decided I wanted to go back to the Mittens and see if I could make a photograph that showed the essence of that monumental place. Paul and I set up our cameras. And waited. And waited. The sun settled behind the clouds in the western horizon and Paul said, "It's over." He packed up his gear. But I had this feeling. I had an intuition that something wonderful might happen.

This situation arose because I'd had years of experience and practice in making photographs, observing conditions, and analyzing the factors that go into the making of a photograph. Most important, my feelings about photography have nurtured a constant attitude of receptivity. I know I must be incredibly present, in the moment, to make a successful photograph. I must turn off all the internal dialogue in my head, all the fears, all the things that do not relate to this moment and this photograph.

It's almost a hyperreality. I am conscious of everything present—the clouds, the dust in the wind, the grit of sand under my feet, the sound of a hawk's wing—it's all palpable. Everything is intensified in that moment. Time stops.

To be so present also means that a long time ago I gave myself over to photography. I expected nothing in return. I just wanted to spend my life making pictures. Photography is the first thing I think about in the morning and the last thing that's on my mind when I drift off to sleep. It connects to every aspect of my life. It's natural that I wait for the light and for quietness.

That evening in Monument Valley, I knew I had to wait. A moment was unfolding and I had to be present for the entirety of it. The sun had been heading toward the western horizon. I noticed a distant group of clouds coming in from the west, swirling, building, changing shape. I hoped they would hover over the Mittens just long enough to catch the last light of the day. The Mittens seemed to be beckoning to the clouds. They floated over the stone floor and darkening tower, slipping into the coming night. At the moment I made the exposure, the setting sun broke from the clouds and illuminated the foreground. The photograph conveys a sense of the vastness of this place, and the significance of the Mittens reveals itself.

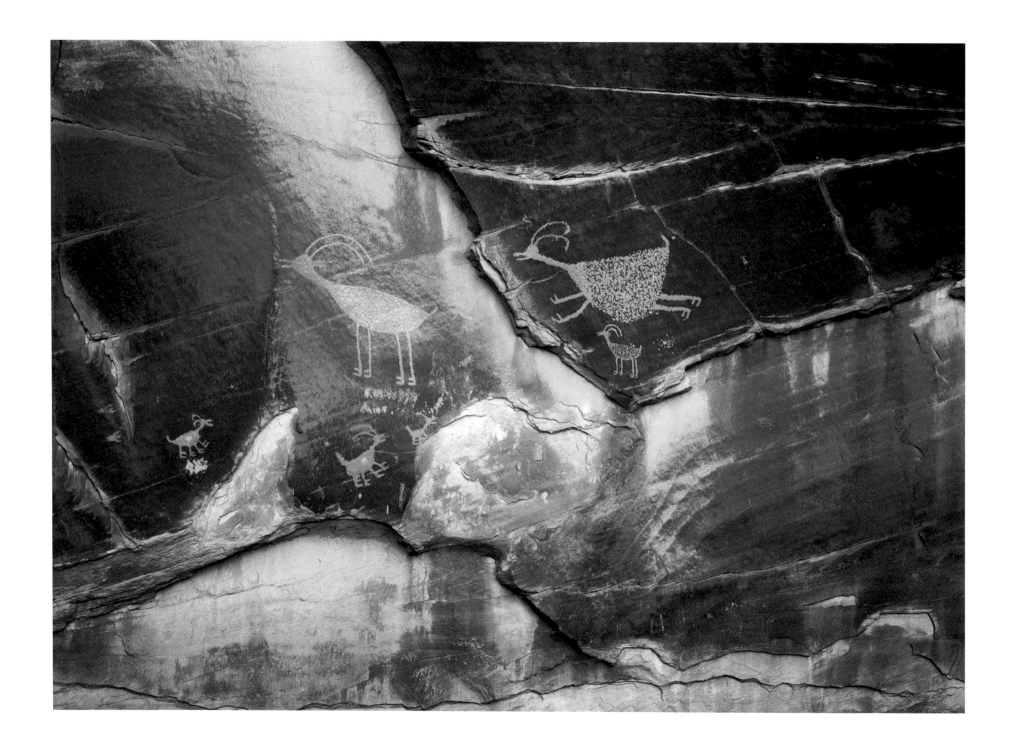

ANASAZI PETROGLYPHS
MONUMENT VALLEY, UTAH, 2003

ROBIN JONES

TSEBII'NIDZISGAI IS "THE VALLEY WITHIN THE ROCKS." ON MAPS IT is known as Monument Valley, Utah. The wind blows and the sun shines fiercely down on the vastness that was once part of the Paiute Indian reservation. In 1921, the Utah state legislature offered this Native farming community land to the north, better suited to agriculture, and the Paiutes left. The land became public domain.

An enterprising couple, Harry and Leone (Mike) Goulding, bought 640 acres, one square mile, of land in Monument Valley. The Diné, or Navajo Nation, got the rest as part of their reservation. The landscape is vast and empty, what artists see as "negative space." People tend to claim emptiness through names, and that is how one travels through Monument Valley— from one named point to another.

Harry's Picket Fence, named after Harry Goulding, is the first seen formation: buttes, pinnacles, sheer-walled cliffs glowing red and umber under the sun, purple and dim green under thunderclouds. Totem Pole Monument is a spire of sandstone, shale, and siltstone stretching to the sky, though no Diné ever built a totem pole. You can travel through Stagecoach Wash and past Clye Butte, the North Window, and Yei-Bi-Chei Rocks. The movie director John Ford has been remembered. You can travel up to Ford Point and look at the vast panorama.

Driving down the roads of Monument Valley now, you see the homes and buildings of the Diné who live there. More than seven thousand years ago, it was ancestral Pueblo Indians who hunted and gathered here. Later they began to weave baskets, grow maize, make clay pots, and settle into more or less permanent dwellings. They lived in cliff overhangs, in pit houses, and in houses with low, rock slab walls topped by wattle and daub. By around 1300 AD they were living in villages with many-roomed dwellings and were developing irrigation systems. Then something happened.

It might have been a drought, or warfare, or a plague. On a less sinister note, perhaps they simply outgrew their surroundings and sought more fertile land and a wetter climate elsewhere. In any case, the homes and work sites of the ancestral Pueblos were deserted long before the Zunis, Hopis, or Spaniards settled this territory.

The Diné call the ancestral Pueblos "Anasazi," which has been translated as "enemy of old" or "ancient enemy." No one knows what they called themselves. There are traces of their lives here: granaries, kivas, pottery. On the rock walls are pictographs and petroglyphs—Kokopelli (the humpbacked flute player), painted handprints, birds, bighorn sheep, lizards, snakes, deer, and antelope.

CRAIG VARJABEDIAN

Paul Cousins and I were traveling in Monument Valley with a Diné guide, who took us to these petroglyphs. Petroglyphs are images pecked or chipped into stone; pictographs are images painted on stone with either gum or plant pigment. Either can be hard to see. You can walk right past one in the morning, and in the afternoon it becomes revealed by the setting sun. You have to know where to look, and when, to get good photographs.

A long time ago the Anasazi built these cliff dwellings in Monument Valley.

(*Ancient Cliff Dwelling, Monument Valley, Utah, 2003.*)

Because the color of the rock face is similar to that of the images, the petroglyphs sometimes blend right in. The original works must have been sharp white when first chipped, but now they're aged and darker. An overcast day or open shade is good for making photographs of them.

Our guide showed us an overhang that, together with a little fence, protected some petroglyphs in what is called Mystery Valley. The figures in this photograph looked to me like sheep—ewes with their lambs. The texture of the ones on the right is wooly and vibrant. There were other images on the wall, but this group appealed to me because of its realistic detail and its composition.

I've rarely photographed petroglyphs. I feel that they're somebody else's work, and why would I want to photograph that? I'd rather just enjoy them. Long ago, someone worked on a stone in order to communicate, and I like to think of myself as one of the receivers. The people who put them on the wall wanted to show something, to share something with others. That's what I want to do as well, with my photographs.

But this one moved me. I didn't see my photograph of it as a document, a record of someone else's expression; I saw the whole image within a much larger context. The chips and fissures and patches where pieces had fallen from the rock wall formed a representation of the Monument Valley landscape itself. The wall looked like the natural terrain in which these animals lived—the Southwestern landscape. The dark patina and texture of the rock provided a tableau for the etchings and the light. I see cirrus clouds in the upper right, and the fissures in the rock form elements of the land.

I also love the little animal hiding on the left side of the photograph. I don't remember seeing it when I was making the photograph—it showed up later, after I developed the negative. When I photograph with my view camera, the image I see is upside down, which might have something to do with why I missed it.

Some petroglyphs have been harmed—chipped off or added to—actions that show a disrespect stemming from a lack of understanding. Perhaps some people think they are simply valueless graffiti. But just as it took many years to understand DNA and unlock the human genome, so it might be years before someone finds the right key to understanding Southwestern rock art. To lose it to vandalism would be a terrible thing. The best we can do now is to learn all we can from it and preserve it for future generations.

After photographing the petroglyphs that day, I remember turning around to see a Navajo sheepherder moving sheep across a field opposite us. I looked at those very alive animals, bleating, walking, running, grazing on whatever green they could find. I looked back at the wall and the figures chiseled on it. I didn't know if they really were sheep, what they meant, or why they were there. I just saw life in the images, however old they were, and my photograph shows that life as well.

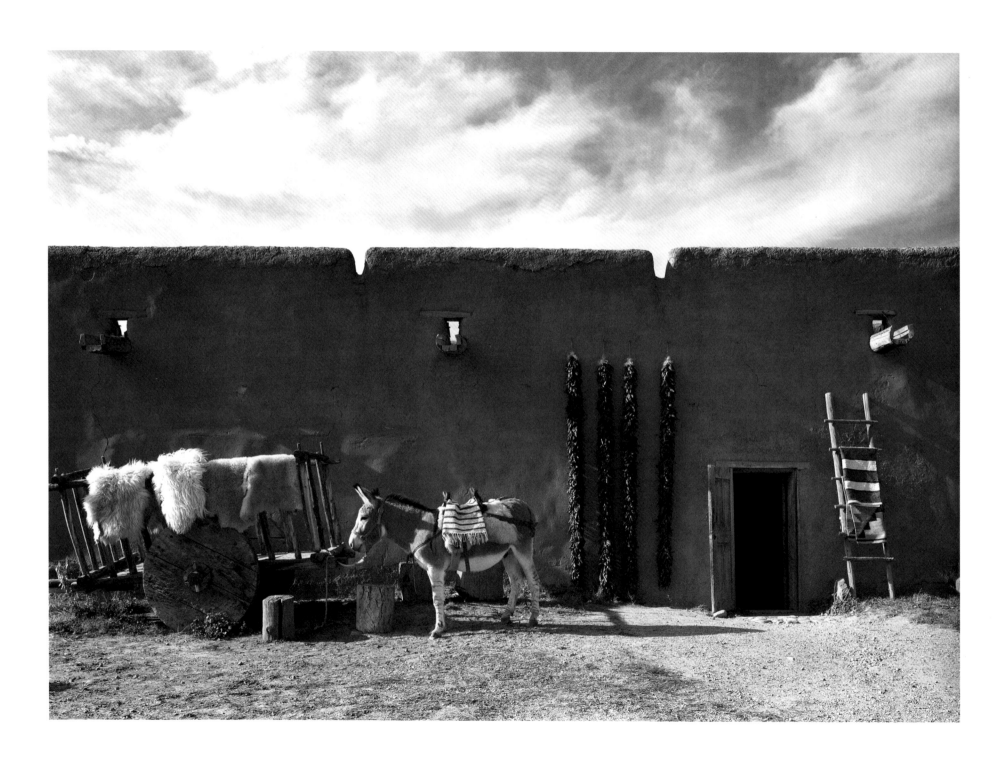

PETE VISITS THE MARTÍNEZ HACIENDA
TAOS, NEW MEXICO, 2003

Severino Martínez ended up in jail, his legs in stocks, over a mule. He had argued that a mule from his herd had been "borrowed" by a Vicente Trujillo and then traded for a servant/slave. The mule was also claimed by Francisco Sánchez, who had given Trujillo permission to take one of his mules for the trade. Martínez had objected to Alcalde Juan de Díos Peña's handling of the case, accusing him of favoritism and rejecting his authority. Peña had him seized and thrown into jail. All were eventually reconciled, and Martínez won the judgment, perhaps a sign of his influence more than of accuracy, for many had testified that the mule wore the Sánchez brand.

ROBIN JONES

ANTONIO SEVERINO MARTÍNEZ ESTABLISHED THE Martínez Hacienda in 1804, southwest of Taos. He and his family wanted a home where the soil was good and water readily available. The Martínez dynasty had begun in 1787, when Severino, age twenty-six, married María del Carmen, fourteen, in Abiquiu. The marriage was successful and productive: all six of the couple's children lived to adulthood and outlived their parents. The hacienda began as a four-room adobe structure and grew as the family prospered. And prosper it did, seemingly in all things: community politics, religious presence, and market economics. The hacienda remained in the family as New Mexico changed hands from Spain to Mexico and finally the United States.

Antonio Severino Martínez was a powerful man, not the wealthiest in the area but influential in matters of church and state. He became all the more influential when his oldest son, Antonio José Martínez, a widower with a young daughter, became a priest. Padre Martínez was a main character in Willa Cather's *Death Comes for the Archbishop*, a fictional tale based on French bishop Jean Baptiste Lamy, who was sent to Santa Fe at a time of crisis and reformation in the church. Although Padre Martínez is better known, Antonio Severino's youngest son lived on the hacienda, continuing the family's position of affluence and power.

The Martínez family held the hacienda until 1931, when the widow of one of the great-grandsons sold it. It passed through the hands of two more owners and fell into disrepair, prey to the weather and vandals. In 1969 the house and three

and a half acres around it were sold to the Kit Carson Memorial Foundation, which has restored and reconstructed the building.

CRAIG VARJABEDIAN

The board of directors of the Taos Historic Museums asked me to photograph the Martínez Hacienda in celebration of its two-hundredth anniversary. It was an unexpected honor, and I was delighted to be asked. I had spent many wonderful hours photographing there, by myself and with students. The people working there are always helpful and a fund of great stories.

It was, nonetheless, an intimidating project. The hacienda is a huge adobe building, a rectangle with small windows and simple doors. The bare edifice was designed that way for defense—to ward off attackers. The monolithic building has no obvious entrance. Usually, there are cues on a building, some indication of where the main entryway might be, but there are none on this one. I spent a day making lots of trial photographs, looking for a camera position and testing for the best light. That night I looked at the images but found that I had not yet discovered the best place to begin photographing.

I have always liked old New Mexico photographs, especially those of John Collier Jr., from the 1930s and 1940s, one of my favorite periods in American photography. Collier had been a photographer for the Farm Security Administration, taking photographs of the lives of working-class people during the Great Depression. His goal as a photographer was to show what was going on around him, specifically people's relationship to their environment. His preference was to be out in the field, seeing places, events, and people—which is my preference as well. He admired the photographs of William Henry Jackson; in a 1965 interview with Richard K. Doud, Collier said that Jackson knew the old West "wasn't mythical, that

Pete and his owner Stoney Wellman
during a break in the shoot.

his records were going to be the first records of the Far West seen by the East. And this was a heroic and very important work." Because Collier had grown up in the Southwest, he was comfortable and happiest working in the West. He made many photographic studies of Spanish American and Native American homes—interiors and exteriors—that showed a way of life often based on the simplest necessities.

With Collier's photographs in mind, I decided to try to re-create a sense of what he might have seen. I would "dress the set" with age-appropriate items from the hacienda collection: a Rio Grande blanket, some sheepskins, some red chile ristras, and a wagon. I wanted a present-day photograph with a flavor of the past.

I asked my friend Stoney Wellman if he would bring his donkey Pete to the hacienda. I wanted a focal point other than the hacienda itself, and Pete represented more than two hundred years of donkeys on ranches. As a representative he looked quite suitable, but as a photographic subject he left much to be desired.

I found a place to photograph, set up my gear, and with the help of museum staff worked on arranging the set to my liking. Then Stoney brought Pete into the scene. By then, Pete had a bit of an audience. Stoney had brought a couple of buddies with him; Karen Young, the director of the Taos Historic Museums, dropped by; and hacienda staff wandered in and out, giving us amused looks. Pete decided to behave, well, like a donkey.

He would not hold still. He'd back up a few steps and then go forward a few steps. He'd switch his tail. He'd wave his head around. I'd get ready to make the picture and Pete, as if he knew I was ready, would change his position. I'd try to anticipate when he would settle down and get ready for him, and then he'd move his rump toward the camera.

Now, I'm not complaining. I know the difficulty of photographing animals—they don't have the ego or the awareness we humans have when our pictures are taken (or I don't think they do). They just react to situations. And eventually I saw that Pete's behavior, believe it or not, made for a better picture.

All during this time, a bank of clouds had begun to move in from the west. When we had first arrived, the sky had been a beautiful, brilliant, clear New Mexico blue, without a cloud in sight. I believe that clouds are important to an image, and they appear in many of my photographs. I suspect they have become a kind of trademark of my work over the years. I find myself soaring when I look out at a big New Mexico sky of blue and see clouds racing across the heavens. The New Mexico photographer Laura Gilpin said she didn't really like "naked skies" in her pictures, and I agree.

And here came a mass of cumulous clouds, the final piece of the stage setting, thanks to Pete's ornery self.

I felt that the scene was now completely dressed and ready to be photographed. Apparently, so did Pete. Cindy Lane gestured to Stoney to put some feed on a stump in front of Pete. Seeing it, he started to eat and finally stood still, chewing. The clouds stood still, the sun shone, and I made this picture. I must have exposed twenty or thirty sheets of film. Happily, two negatives showed Pete sharp and in focus. If he hadn't been true to his nature, my photograph wouldn't have been as good—I would have made it too early. So I learned that if a donkey wants to be a donkey, let him.

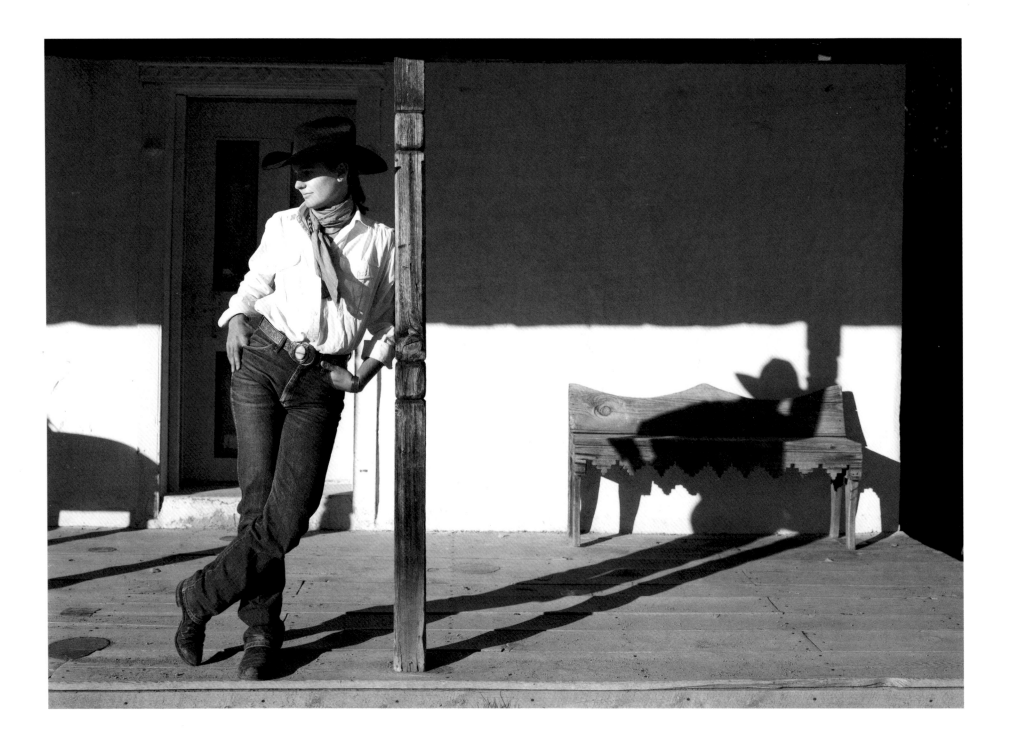

SADIE LOMBARDI, HORSEWOMAN
SANTA FE, NEW MEXICO, 2003

It's the way you ride the trail that counts.

—Dale Evans

CRAIG VARJABEDIAN

AFTER PHOTOGRAPHING ARCHIE WEST, I FELT INSPIRED to make more portraits. There are plenty of wonderful folks to photograph out here in the Southwest. I met Sadie Lombardi at a local department store, of all places, and I knew immediately I wanted to photograph her.

I was shopping with my assistant, Cindy Lane, when she nudged me and said, "Look at those women over there." There were two cowgirls, dressed in their work clothes. One had on a black hat, a bandana, cowboy boots, and a white shirt that seemed almost luminescent. "We've got to meet them," I said to Cindy, and she agreed.

Sadie was so striking. The store was already a visually busy and noisy place, but she and her friend, Christine, stood out as something real, natural, and beautiful in the midst of all the glitz and promotion. Cindy and I both sensed that

Sadie was the real thing. I remember looking at the floor and noticing her well worn cowboy boots with signs of the stable still evident.

After a brief exchange, I gave her my business card and the names of some other people I had photographed. She knew some of them, especially Archie West. She had danced with him at La Fonda. Later that day she emailed me and we set up an appointment. We've talked with each other and worked together many times since then.

Now certainly Sadie is a beautiful woman. But I wanted to make a portrait of her that glimpsed the authentic person beneath the surface beauty. I wanted to peel back the layers to discover an insight or surprise, which is more difficult and challenging than capturing a superficial likeness.

Sadie is committed to the horse world. The spectrum of cowboy life is open to lots of interpretations. She is absolutely in love with this life and willing to live a minimal existence in order to follow it. It's her passion. The photographer Alfred Stieglitz once said that "photography is my passion, the search for truth my obsession." That's Sadie—horses are her passion, and the cowboy life, based not only on actions but also on morals, is her obsession.

Success for her is probably a ranch somewhere, training horses and living life on her terms.

For some time I had been exploring the question, "What does it mean to be a cowboy today?" I figured Sadie was someone who could tell me.

SADIE LOMBARDI

I know that what "cowboy" means to me has changed since I was young. Growing up back East, I think I had the Hollywood version in my visual memory. And when I saw rodeos on TV, I couldn't relate to them.

I feel sometimes that there's not a lot of horsemanship displayed in rodeos today. The traditional rodeos were about the art, about the many skills a good horse and rider acquired doing their work on the ranch. There are some old rodeos and some new ones that are returning to the contests of skills of the old californios and vaqueros, where some real horse training has been applied to meet an impressive end. They are a totally different class of rodeo.

I like to hear stories about traditional Western times, but I'm glad I wasn't born back then. Most people think they would like it, but they probably wouldn't in reality. After all my time out here in the West, I'm not sure I'm a cowgirl. I don't work with cattle, I work with horses. So I'm a horsewoman. But I believe in the cowboy tradition—of people who are independent and proud. They base their decisions on personal values. So, yes, I'm a cowgirl that way.

The term "cowboy" is used fairly loosely, sometimes in ignorance. Some folks may learn how to ride and take care of cows. They'll do it as a hobby. They may "keep a few cows" and learn roping. But I can't say those people are cowboys, in the old sense of the word.

I guess that cowboying to me is a craft. It's a skill learned through experience, where a reputation speaks louder than any degree could. It's

an honor to live up to the term. Simply put, it is a position within the business of ranching. I haven't spent much time around that way of life—that's why I hesitate to call myself a cowgirl. But someday I hope to call myself one.

Traditionally, cowboys didn't own horses. They might own their own saddle and gear, but they depended on the ranch remuda for a string of horses. Some people would say a cowboy is someone who does things only from the top of a horse. But things change. Now you need a truck and trailer, and lots of ranches use ATVs in place of horses. But there are still some ranches with working horses, cowboys, and ranch hands. Cowboy traditions endure because somebody did something that worked.

A real ranch has a crew of good cowboys who are part vet, part mechanic, part horseman, part cowman. They're adaptable. I knew a guy in Wyoming. He was out doctoring and had a calf roped when his cell phone rings. So he holds the dallies with one hand and answers the phone with his other and somebody snapped a picture. Now that photograph is on a phone book—and that's pretty much the modern cowboy. We're all open to new ways that will make our own work easier.

I was born in Hartford, Connecticut, which has more horses per acre than anywhere else, I've heard. As a kid, I wasn't into the cowboy thing but I was into horses. I didn't want a horse; I wanted to be a horse.

I've been told that it's rare to do what I did, to move so far from where I grew up and do something different from the rest of the family. But most of my family has done that—their own thing. And for me that one thing has been obvious all along. Blatantly obvious to everyone else—but I wouldn't admit it—that horses were it. Now I know and that's what I do.

I learned to ride back East. There wasn't a lot of Western riding, more hunting and jumping. It felt very competitive. I sought out a barn that was more family oriented. A woman named Sharman owned it. She was

an ex-barrel racer and former cop who had lots of animals around her all the time.

I grew up there. The first time Sharman took me for a ride, she wanted to see how well I could ride. We got to some cornfields up on a hill and she said, "I'll beat you to the end," and took off. Well, my horse just took off after her. I didn't have time to think. I was a twelve-year-old skinny bean and no problem to my horse; I hiked up in racing position and rode it out. And beat her. "Woo-hoo," she said, "this girl can ride!" And she never worried about me again. She started me off leading trail rides and things like that. I didn't get much formal instruction there. I rode for fun.

I remember the first time I really cantered. What a great feeling. I love the first time you click with a horse and everything goes smooth and you become one with the horse. At my first jumping show, I had an Irish half-draft named Tucker. He refused the jump three times, so they brought out a young thoroughbred mare named Babe. What a difference. It was like a dream, it went so perfectly. Whenever I feel out of sorts with a horse, then I remember jumping that course with Babe, to recenter myself.

I went to college at Bennington and from there went to Wyoming. My brother was there at a leadership school, and he got me a job on the ranch. We'd ride out to where the classes were, out in the field, with food. I guess we were glorified grocers, but it was fun. We'd head out with a string of pack horses, get to the camp, and the students and teachers would be so grateful: "Eggs! Steak! Milk!" Things like that. Then we'd go back down the mountain again. If anything we were more in the tradition of mountain men, packing things along, than cowboys.

ON WORKING WITH CRAIG: I had been a model before, for a marble sculptor, so I was used to holding still. But I've always hated having my picture taken. However, right about the time I met Craig, I wanted a good picture of me and my life here, for my family. My mother especially wanted one. So with Craig I just tried to act like myself. Of course, when it was just me, it was easy. When it was me and my horse Elwood, it was a bit more difficult. But Elwood and I had an understanding. All he needed to do was hold still for a while. I learned that once you get his feet stopped, he's pretty happy to just leave them that way. The problem is getting his feet to stop.

Horses teach me patience. All the time.

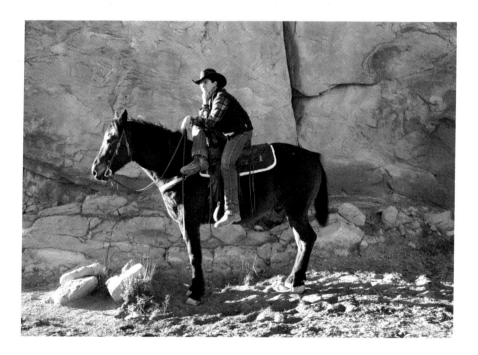

Sadie is a wonderful subject, either by herself
or with her horse Elwood. I made this photograph
of them together at the Garden of the Gods.

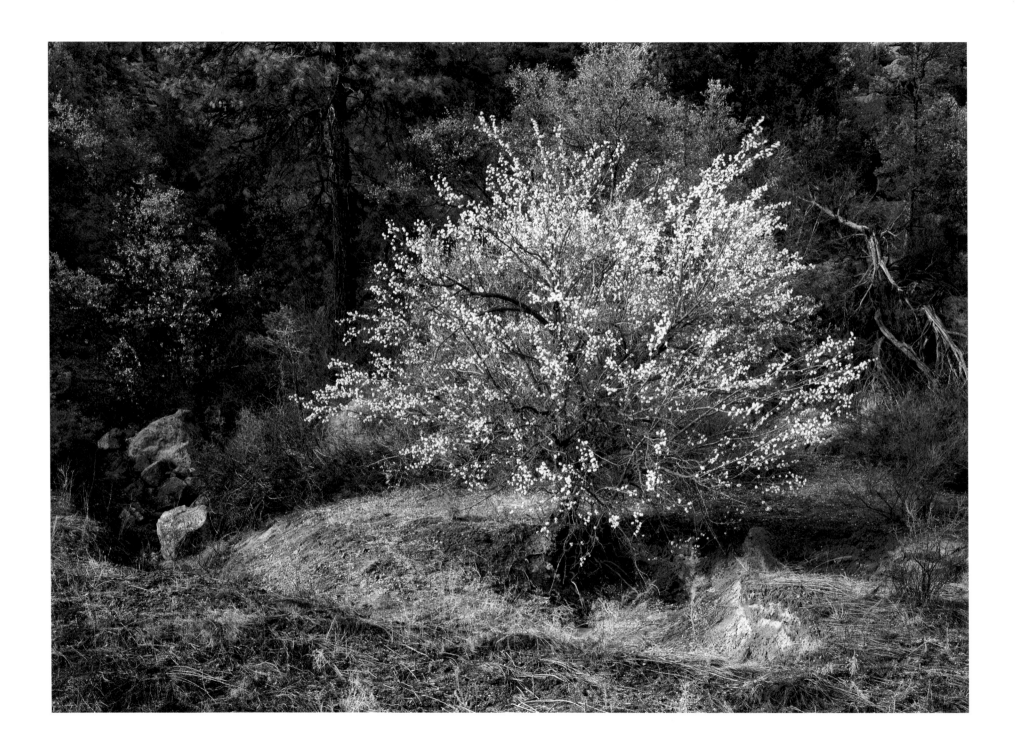

APRICOT TREE, EARLY SPRING
LOS ALAMOS NATIONAL LABORATORY, LOS ALAMOS, NEW MEXICO, 2004

The fairest thing we can experience is the mysterious. . . . A knowledge of the existence of something we cannot penetrate, of the manifestations of the profoundest reason and the most radiant beauty . . . it is this knowledge and this emotion that constitute the truly religious attitude.

—Albert Einstein, "The World as I See It"

CRAIG VARJABEDIAN

THIS LONE APRICOT TREE SITS ALONG THE TRUCK ROUTE TO THE mesa-top site of Los Alamos, New Mexico. Most people are familiar with Los Alamos as the place where scientists such as Edward Teller, Robert Oppenheimer, Niels Bohr, and Richard Feynman worked during World War II on the Manhattan Project—the atomic bomb.

Today, an international body of scientists, graduate students, interns, and administrators works on a multitude of projects at Los Alamos National Laboratory. The Lab has so many different branches, offices, tasks, and goals that it's not easy to describe the organization. Suffice it to say that it is full of minds at work.

Some LANL employees live in the town of Los Alamos, but many of them commute from Santa Fe, Española, or other nearby towns. One way to get up the mountain is this truck route. I like to drive this road because

it's fast and fun. It goes up a narrow canyon, twisting and winding to the mesa much like a Grand Prix speedway. On either side of the road are pine trees, shadows, rocks, and bare ground. There are places where you can park and hike in to see ancestral Pueblo ruins. It's beautiful in a stark sort of way-—somber and dark below the tree line, bright above it.

One day in spring, however, as I was driving the road, I saw this *thing*— a flash of white, a snowball in the midst of the darkness. There was no one behind me, so I backed up and pulled over. I parked by the NO TRESPASSING sign that was attached to a post on the side of the road.

Beyond the road, perched like a fairy among giants, was this little apricot tree in full bloom. I could tell that the tree had flourished despite its isolated and unexpected location, surrounded by the cliffs and boulders of the mountains. Spring runoff had formed what for New Mexico was a circle of lushness around the tree. Rocks that must have fallen from above lay scattered around.

The shape of the branches formed a halo of blossoms that erupted off the tree in an explosion of white and palest pink. The contrast between the blossoms and the darker background was so vivid that they looked like sparks. I searched for words to describe it: a plume of white? A snowball? A sparkling, sparking fire of flowers?

It was a beautiful little tree with its cascading lines of blossoms. It was made all the more curious and delightful to me because I knew what was on the cliff top above it: the Lab's half-mile linear accelerator and neutron scattering center, known as LANSCE (Los Alamos Neutron Science Center).

ROBIN JONES

Most of the property around Los Alamos National
Laboratory is posted with signs like this.

All matter is composed of atoms. An atom is composed of a nucleus, or center, of neutrons (which carry no electrical charge) and positively charged protons, surrounded by a cloud of negatively charged electrons.

At one time, no one thought the atom could be explored, because it was so infinitesimally tiny. But today's nuclear science revolves around exploration of the atom. LANSCE is actually one gigantic scientific instrument used to accelerate atoms to nearly the speed of light. They bombard other atoms in order to break them apart and scatter neutrons to be used for study.

First, the element hydrogen (which is a building block for water, H_2O) is leaked into one end of the instrument. Half a mile away, at the end of the pipe (remember, this is a huge machine), each atom of hydrogen is moving at nearly the speed of light. Collectively, the line of rushing atoms forms a beam of energy that slams into a target at the end of the accelerator. The force of the collision smashes the hydrogen atoms and releases their protons and neutrons, which the machine sorts and sends along to experimental areas. These nuclear fragments can move as a beam, as a continuous line of particles, or as a pulse, like a heartbeat full of protons or neutrons. In the experimental areas, scientists use the beams and pulses to explore the innermost workings of the atom's nucleus, to create radioisotopes for medical treatment, and to study the properties and behaviors of materials such as metals, plastics, and even human proteins.

can't remember how many times someone has told me, "Yes, people take pictures around my place; they say they'll send me a print afterward, but they never do."

All my inquiries about photographing the apricot tree were dealt with politely. People at the Lab seemed surprised and pleased that I wanted to make a picture of it, and everyone was most helpful in allowing me access. With a Lab escort and a visitor's badge, I was permitted to enter the property, set up my camera, wait for the light, and make this photograph.

What's going on at LANSCE is energy release, incredibly swift and powerful. I see the blooming apricot tree in a similar light. Compared with what happens at LANSCE, the energy release is gentler, but it is just as important. We humans can bombard atoms and split off neutrons to use for our own devices. But we have been constant witnesses to a more primal release of energy. We live surrounded by beams and waves of light, scents, textures, and colors—the generation and renewal of the natural world around us. Nature needs no human intervention. Its mystery continues, day in and day out, with its own cycle.

The scattering of blossoms in the wind is a pulse felt in the heart of the viewer, who marvels at the continuation of life. We are bombarded with beauty every day.

CRAIG VARJABEDIAN

Because this tree was on Lab property, I had to make a series of phone calls to get permission to photograph it. Photographing in New Mexico—or anywhere else—calls for acts of courtesy. One shouldn't wander onto somebody's property without asking first. One shouldn't make a photograph of a place or subject without asking for permission. And when all is said and done, one should always say "thank you," get an address, and send the property owner a copy of the photograph. I

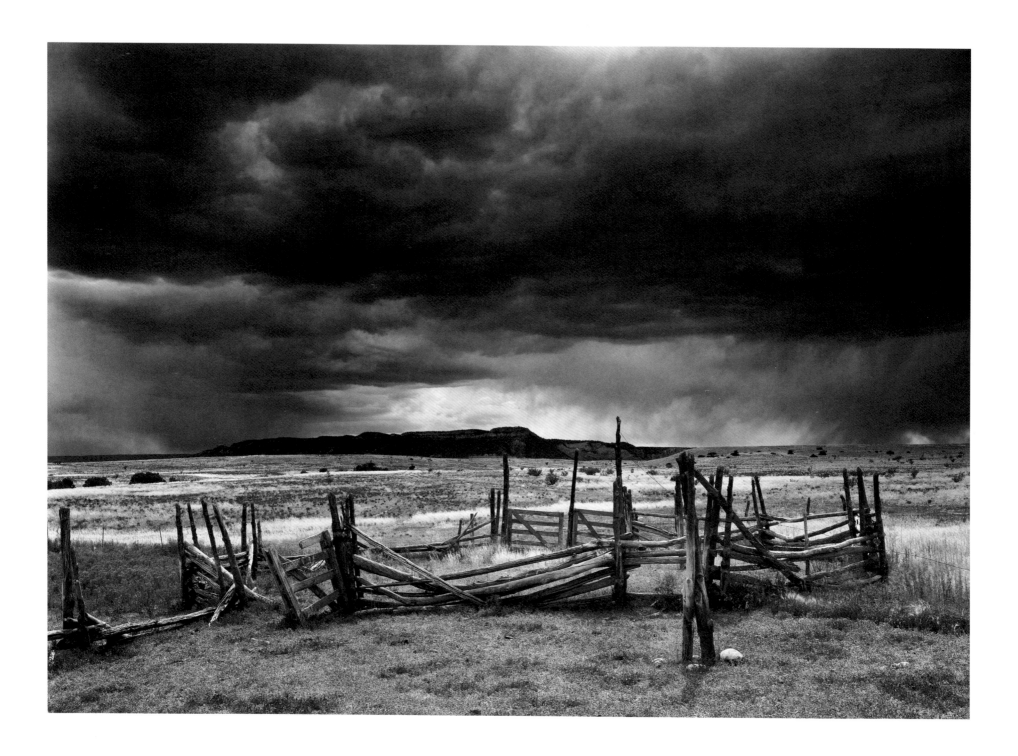

THE OLD CORRAL
GHOST RANCH, NEW MEXICO, 2005

This story is dedicated to Floyd Trujillo, who took us to the old corral.

CRAIG VARJABEDIAN

I CALL THIS PLACE "FLOYD'S CORRAL." FLOYD TRUJILLO KNOWS
Ghost Ranch. As a young boy, he swam in the old swimming pools. As
a teenager, he worked for Georgia O'Keeffe at her Ghost Ranch house,
stretching canvas, driving her to painting sites, cleaning, and cooking.
When he was older and back from the army, he joined the Ghost Ranch
staff, eventually retiring after more than thirty years.

The corral was built early on, and Floyd says he was sent over to repair
it from time to time. He put a lot of time and energy into it. To Floyd, the
past means a great deal—I could tell when he took me out to the corral
the first time. He just wandered around, shaking his head. It looked so
forlorn. It had been a useful corral, and now it wasn't.

To Floyd, place is very important. He's had opportunities to travel, but
he always comes back. There's something here that draws him—some-
thing he might call *la querencia*, love of place or homeland. His birthplace is
Vallecito, in the mountains overlooking the Chama Valley. It is his haven,
his respite from changes that trouble him. He's seen this land change and
the attitudes of its inhabitants change, too.

89

Floyd Trujillo sits at his dining-room table. He's in blue jeans and work shirt, and only his mustache shows signs of gray. In the living room is a wedding photograph of him and his wife, Virginia. In this picture, Floyd has a flat-top crew cut, a thin mustache, and the white jacket of weddings of the fifties. Virginia looks a bit like Ava Gardner, only friendlier, all smiles and satin, with a long white train looped over the floor. They've been married since 1959.

Floyd knows Ghost Ranch as well as anyone, if not better. "I remember first going there when I was seven, with my mother, when your uncle"—he nods toward Virginia—"your *tio*, Herman Salazar, was the foreman. Every year the older people would come to mix adobe mud. You have to remud the buildings' walls every year. The women would put it on the outside walls and fix the cracks. The people got too old; the younger ones would have to learn and come take over."

In 1961 Floyd started working at Ghost Ranch. "We had a grazing program starting in the early 1960s where we leased land out for cattle from November to April. Before, the land had been overgrazed, and with real dry weather there was more harm with grazing than not. The grazing program meant we tried out different planting techniques: furrow planting or pit planting. The best grass was blue grama grass. The seed can take up to six years to germinate if there is not enough water, so you have a chance with it. The places grazed did better than places not grazed. A lot of plants could come up because the cattle were fertilizing the fields and the seeds were being carried around by the cattle. Plus, they'd eat up old stuff, and new growth would move in.

"I did all kinds of things on the ranch. I put up fences; I took care of cattle. I guess I'm a cowboy, in a way. My son Virgil and I consider ourselves cowboys because it means a man with cattle. It doesn't mean a man with a horse; it means a man with cattle. Normally, I think a cowboy is someone at the rodeo, riding bulls, stuff like that. The guys in the movies and rodeos, they do it daily. We don't practice; we just do it when we need to do it. We don't call it a sport; we do it for work. Cowboys do roping when branding season is here. Especially out on the range. We can't have a corral everywhere we have cows. It'd be a lot easier. I wish we had more corrals. Cattle can be ornery. And they are stupid. They don't learn. They never figure out they shouldn't go into certain areas for water. They get stuck and drown. On the other hand, I'd rather be dealing with cattle than people. Cattle don't talk back.

"The most important thing to know about Ghost Ranch is to take advantage of the scenery and tranquility. It took me many years of going someplace else to appreciate what we have here. I took it for granted. You go away, and you can see things in a different way. Look at the land, the whole geography—the beautiful hills, different soil and colors, different plants. I respect the land. My way of thinking is if I can't improve it, leave it alone—leave it for the generations to come."

Floyd is going to take Craig and me beyond the gates of Ghost Ranch. We're going to the pasturelands, to a place where Floyd used to bring cattle. But before we go exploring, we stop off at the dining hall for lunch. Floyd rarely visits the ranch since his retirement, and today's return is a homecoming. It's a bit like dining with royalty. The various staff members see Floyd, stop, wave, nod their heads, and grin. One ranch hand comes over, tilts a chair around to straddle it, and sits to chat in Spanish. He tells us, "This man here taught me everything I know. I learned a lot from him."

We head out after lunch. On our way, four donkeys cross the road ahead of us. They're a fuzzy mix of colors, and they look at us curiously. From the back seat, Craig asks me to pull over. He grabs his digital camera

and clambers out. Floyd and I look at each other, sigh, and clamber out, too. Floyd tells me that his son Virgil, the land manager at Ghost Ranch, got the donkeys recently as a way to make the ranch more ranchlike.

The donkeys are grouped around Craig. Not close, but close enough to watch him, and he is focusing, backing up, coming closer, and making his photographs. "Are they friendly?" he hollers to Floyd. Floyd and I waste his time for a bit with foolish answers like, "Sure, climb on and you'll see." Craig shoots back, "Floyd, I'll give you two bucks to ride one," and this becomes his line for the afternoon: "Floyd, I'll give you two bucks . . . " Floyd and I eventually test one by patting it. It proves docile, batting its big brown eyes at us. I decide to make a try for Craig's two bucks and hoist myself on its back. Floyd, a little startled, grabs hold of its forelock and keeps it steady. The donkey itself doesn't seem to mind and stands quietly while Craig takes a photograph of the three of us—Floyd, me, and donkey.

Back in the truck, we drive past fences, gravel pits, the old landing strip. We're in the flatlands, full of tufted and dried grasses and bushes. And here, hidden from the road, is the old corral. It's a large ruin of wood and timbers, brush growing inside and around it. Although falling down, it keeps something of its original form: posts stuck deep in the ground support the beams set across them. A gate still stands, though all around it are fallen rails. Beside the corral stands a windmill with a pond below it, reflecting the blue sky and clouds. A dust devil whirls about a mile away, big and brown.

We are standing silently, looking at where Floyd used to work. The windmill creaks. A large metal cattle tank stands next to it. Floyd says he built the tank and poured the concrete bottom. "I used to have to come here and oil the windmill and take care of it. Sometimes the wind here was so strong, we'd come out and find the fan belt on the ground. I'd have to fix the whole thing again." Floyd lays his hand on one of the weathered vigas. "When I was working at the ranch, I'd come out here every year and

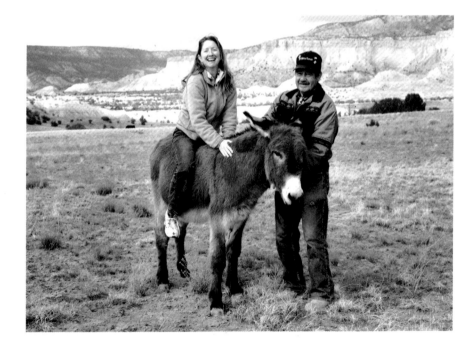

Floyd Trujillo holds Jackson the burro steady
for Robin Jones to win my "two buck" challenge.

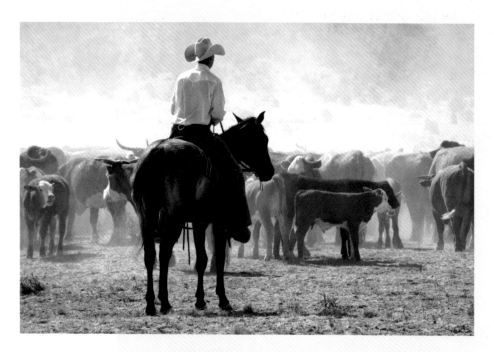

"Often for thirty-six hours continuously in the saddle, the hardships of their lot are apparent; cold black coffee, without sugar, drunk whenever the opportunity offers, is the sole luxury of the cow-boy. With a piece of bread in one hand and some jerked beef in the other, he will ride around a stampeded herd, eating as he goes, and as happy as a king on his throne." Louis C. Bradford, "Among the Cow-Boys," Lippincott's Magazine, June 1881.

(Working cowboy, Bell Ranch, New Mexico, 2006).

replace the worn rails and keep it in working order. We brought these out from in front of the dining hall, to replace some broken ones. You can see, these are newer than these here"—he gestures to wood scarred and gray. It still looks tough, tough enough to keep memories in, but not cattle. The wood lies askew; we step over it to walk around the corral.

No one seems to have been out here for years. Maybe in the past, cowboys sat on the top rail and talked about the day's chores or ate lunch in the shade of the tank. The cattle might have lowed and milled here, pushing against each other to escape the vaccination needle or branding iron, mothers bawling for calves, calves bleating for mothers. The noise must have been deafening back then. Now the place is very quiet—just the cut of a bird's wing overhead, a magpie flying by.

Craig climbs up the windmill a ways to see what a photograph from there would look like. He's obviously pleased with what he sees, and Floyd is amused. "Climb on up to the top!" he calls. Craig declines, but—"I'll give you two bucks if you do it, Floyd!"

CRAIG VARJABEDIAN

The day I made this image, I started out early and explored a whole bunch of places. The clouds that day were playing hide and seek. Just as I'd put a film holder in the back of the camera to make an exposure,—poof—the clouds would disappear. I set up my camera about a dozen times because I had a sense that a photograph was waiting to be made, but every time, just when I was ready to make an exposure, the wind would pick up, the light would go away, or the clouds would move out of the frame. Pictures just weren't coming together. I felt defeated.

Sometimes I feel that photography is more about the photographer's mental and emotional state than about the subject. The subject, whether a cloud, a fence, or a mountain, couldn't care less. What matters is the ability

to get out of the way of one's expectations for a particular image and to make photographs of what one is given. One thing about photography, it sure keeps you humble.

The weather was hot. I was running out of film. The day was waning. I got back in the truck and drove down the highway to go back to the Ghost Ranch darkroom to reload my film holders. As I drove, however, I noticed clouds building in the western horizon and perked up. Maybe there were other possibilities. I suddenly remembered the old corral. When I had been there with Floyd and Robin, I had perceived that the corral was not only a part of the land, it was part of the sky, too—there was a relationship among all three. So I headed over to the corral in the hope that something good might happen.

I drove up the road, through the dust. The clouds were moving in quickly, and I could see many possible images unfolding. Earlier I had fallen into the trap of trying to force subjects to fit within the frame of my camera. Now I felt engaged with the scene and called by it. I was driving as quickly as I could, trying to race the storm to the corral.

I reached the corral and knew I needed to be up high in order to give a sense of it within the landscape. I backed the truck in, fussing with it to get the angle just right. I set the tripod up fairly high and stood on the tailgate to focus and adjust the camera to achieve the view one would get from horseback.

I started making decisions quickly, intuitively, because the scene was unfolding so fast. The sky was getting darker and darker, and lightning was striking all around. I reached inside the truck, picked out what I thought would be the appropriate lens and filter, and attached them to the front of the camera. I focused the image on the ground glass. I had just enough time to take a light-meter reading. From the result, I set the lens to the appropriate f-stop and shutter speed.

And just then, a hole opened in the tempest of clouds and illuminated the scene. The foreground glowed. I had to readjust the lens for the extra light that had appeared. Miraculously, I was ready. I said, "Oh my God, look at this," and made the photograph.

And then, with a crash of thunder, the rainstorm landed on top of me. I packed my gear as rapidly as I could into the back of the truck, jumped in the cab, and drove off. I had to jump back out again to unlock the gate, then drive through, go back, and relock it. All the time rain was cascading down. I was lucky to get out—the pasture was turning to mud.

I went back to the ranch and sat out the rest of the storm in the safety of the dining hall. I was thinking about the grandeur of what I had witnessed and the danger of being there at the same time. Upon reflection, there was a certain risk in making this photograph: I was standing up high on the truck's tailgate, near a metal windmill, in the middle of an electrical storm.

I suppose Floyd and other ranch hands risked their lives, too, but they probably didn't think about it. It was just work to them. It took a lot of strength to do what they did. I wonder whether anyone appreciates that today, or appreciates the beauty of the places that are deserted now. At the old corral, the windmill is still doing its job, creaking and turning. The sky is doing its job, and I guess I was doing my job, making photographs, just as Floyd did his job, mending those fences, minding the cattle, and watching the sky change.

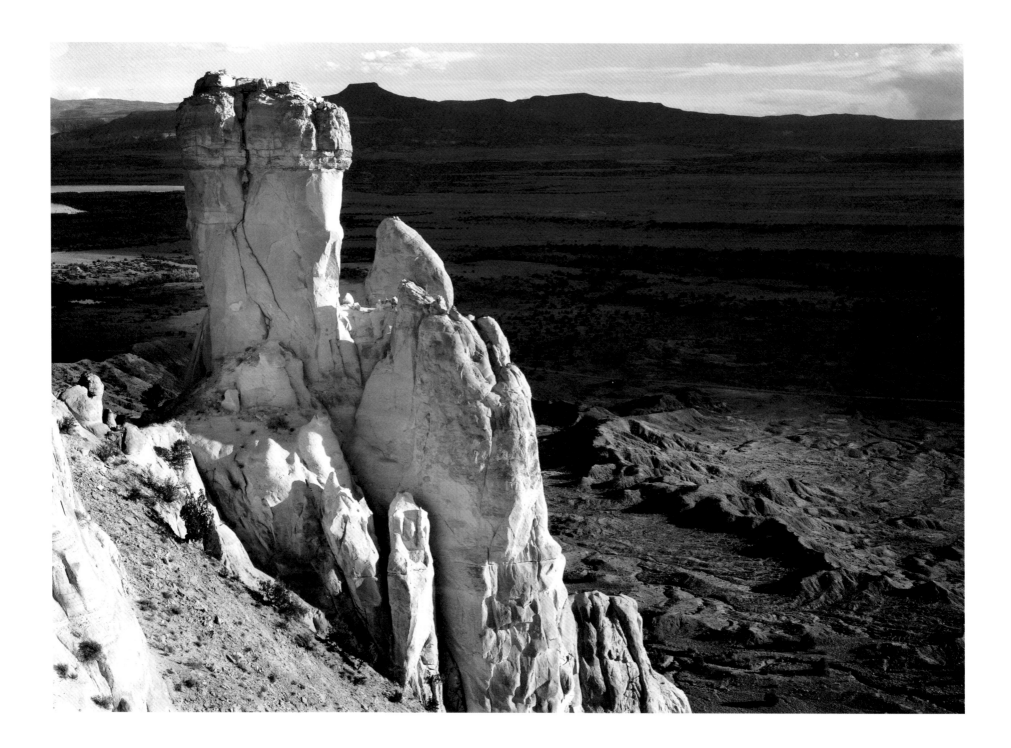

And a man shall be as a hiding place from the wind, and a covert from the tempest; as rivers of water in a dry place, as the shadow of a great rock in a weary land.

—Isaiah 32:2

ROBIN JONES

GHOST RANCH IS PART OF THE PIEDRA LUMBRE VALLEY of northern New Mexico. The valley was first inhabited by prehistoric Pueblo people, followed by the Navajo-Apaches and then by Spanish colonists. In 1766 the king of Spain awarded a great tract of land—the Piedra Lumbre, the valley of "shining stone"—to Pedro Martín Serrano. In 1848, following the war between Mexico and the United States, New Mexico became a territory of the United States, and in 1912 it became a state. Some of the traditionally held land in the Piedra Lumbre Valley was scattered among family members or lost; much of it passed into Euramerican hands.

In 1892, two brothers homesteaded in the valley up toward Yeso Canyon, past Abiquiu. The Archuletas were menacing—they were rumored to rustle cattle and murder travelers, burying their bodies in a well. Their place became known as Rancho de los Brujos, the ranch of spirits or ghosts. Eventually, one brother killed the other and fled. Years went by, and Rancho de los Brujos passed through a series of owners until, in the 1920s, the Bostonian Carol Stanley bought it and turned it into a dude ranch. One story goes that her husband, the cowboy Richard Pfäffle, won it in a poker game. Stanley sold the ranch to the philanthropist and conservationist Arthur Pack in 1936. He expanded the "dude" aspect of the ranch while experimenting with grasslands and cattle ranching.

Pack offered a visiting artist named Georgia O'Keeffe space in which to live and paint. She fell in love with the place. She is supposed to have shown up unexpectedly one day to find the cabin she normally rented already occupied and to have charged off irately to demand that Pack throw the interlopers out. She eventually bought a small house on the ranch from Pack, to make sure there was always a place ready for her.

After raising his family and retiring, Pack presented Ghost Ranch to the Presbyterian Church, which uses it as a conference and retreat center.

Ghost Ranch is twenty-two thousand acres of sand and sage, plains and mesas, and flame-colored cliffs. A monstrous thunderhead of gray and purple can swallow the sky, yet vanish in fifteen minutes, leaving behind a land drenched in shadow and radiance. One lone flower may bloom in its desert—a stray yucca trying to pierce the blue sky. Rock and sand mingle with dinosaur bones and oceanic fossils. The absolute beauty of cliffs, plains, hills, and sky reveals a purity of line and light. In her paintings, Georgia O'Keeffe caught the cliffs in one gleaming, glowing moment that lasts forever in the minds of her viewers. But in fact the cliffs are constantly changing, reflecting not only the moving sun but also the seasons and the time of day. Ghost Ranch is composed of light, color, and texture, all in transition.

CRAIG VARJABEDIAN

Chimney Rock is a focal point of Ghost Ranch. It's hard to hide from. Even in the narrowest cliffs and canyons, you can still peer around and see it. Hike to Floyd's corral—you can see it still. Climb Cerro Pedernal and look back, and Chimney Rock commands your attention. It must be the highest place on the ranch. You can't climb to the very top. You can hike only to the mesa's edge at the end of the trail, where a chasm separates you from the chimney itself. My GPS device shows the elevation of that plateau as 6,500 feet, and the chimney is even higher. I guess I've climbed up to the place below the chimney thirty or forty times in the last twenty years.

The paleontologist Edwin Colbert, who was involved in some of the first dinosaur digs on the ranch, described the geology of which Chimney Rock is a part in his 1995 book *The Little Dinosaurs of Ghost Ranch*:

These were the cliffs of Ghost Ranch, running from south to north beyond the Chama River, and in the cliffs we saw a record of Mesozoic history. At the base were red and tan and chocolate-colored badlands, the Chinle Formation that is so characteristic of late Triassic deposition in the Southwest. Above the Chinle beds were cliffs, white and lemon-yellow, representing the Entrada Formation of Jurassic age. And on top of these sheer cliffs was a layer of dazzling white gypsum, like meringue on a lemon pie— the Todilto Formation, also of Jurassic age. Above the Todilto was an extensive exposure of chocolate brown and light-colored cliffs and hills, receding and rising far back. . . . Finally, on the sky-line, was a crested ridge, composed of brown Dakota sandstone of early Cretaceous age. This was Mesozoic history on a grand scale; a sight to gladden the eye of the beholder.

Chimney Rock is a challenge to climb. It's not a casual hike—you've got to want to go there. Almost every time I climb up there, I learn something. I learn more about light. I learn to wait. I learn more about the pulse of Ghost Ranch and the surrounding lands. When I was first photographing the ranch, I was overwhelmed by its vastness. But after seeing it from on high I could feel more of the rhythm of the place. I got a sense of it by watching clouds move across the sky and the light change throughout the day. I've been up on Chimney Rock when the moon was rising and stayed until it set.

I became in tune with Ghost Ranch by observing it from Chimney Rock. And by becoming in tune, I could photograph the ranch. It's similar to portraiture—I make a better photograph when I have some intimate sense of the subject. After twenty years, I finally felt I knew Ghost Ranch well enough to photograph it successfully. This was partly thanks to Chimney Rock.

One thing I find interesting is that Georgia O'Keeffe didn't paint Chimney Rock. She painted most things around it—the Bennett

Chimneys (now known as Puerto Cielo) farther north on that ridge, for example—but I haven't found a picture of this Chimney Rock.

Ansel Adams photographed it, though. Chimney Rock appears in his photograph *Ghost Ranch Hills, Chama Valley, New Mexico, 1937*, a marvelous study of light and form. I hiked out on the ranch to discover where he must have stood to make the photograph. When I found it, I just stood there, waiting for the shadows to reappear as they did in his image of more than fifty years earlier. At about 9:00 A.M., I could see his photograph in front of me: Chimney Rock looming behind the riveting, lavender gray hills.

When Adams made his photograph, he was visiting O'Keeffe. He wrote about Ghost Ranch in a letter to her husband, Alfred Stieglitz:

It is all very beautiful and magical here—a quality that cannot be described. You have to live it and breathe it, let the sun bake into you. The skies and land are so enormous, and the detail so precise and exquisite that wherever you are, you are isolated in a glowing world between the macro- and the micro-, where every thing is sidewise under you and over you, and the clocks stopped long ago.

My photograph of Chimney Rock was made in July. That's "monsoon" season in New Mexico, which is odd to think about because the place appears so desertlike. But we do get huge afternoon storms rolling in, with great thunderheads and lightning.

That day the sky was dramatic. The sun would drop out of the clouds every so often, and the sudden light would clearly define a landscape that had at first appeared flat and lifeless. I had a sense that up on Chimney Rock, a powerful image might be made. I needed to climb up there to see it for myself.

So late that afternoon I climbed Chimney Rock with Melissa Grubb, a summer Ghost Ranch intern from Austin College. Dark clouds were building on the distant horizon, but we headed up anyway. We split the load of my camera gear into two backpacks and took turns carrying the tripod. The weather was cool, which was good, because this was a tough hike. The trail is rocky and steep. Some parts are crumbly and soft—you have to be careful where you put your feet. By the time we got to the top, we were tired. The sky was completely overcast. I hoped that the clouds would break for a brief moment before the storm hit, so I set up my tripod and camera and waited. But a strong wind kicked up, almost blowing the camera and tripod over the side. We could hear thunder overhead. We packed up quickly and took cover.

But after the storm passed over, I got the moment I had hoped for. The sun broke through the clouds, washing the chimney with a golden glow. I had a bird's-eye view of the plains. They stretched out like an ocean—miles of flowing land and shadow, waves of desert rushing between this highest peak and the distant call of the Pedernal.

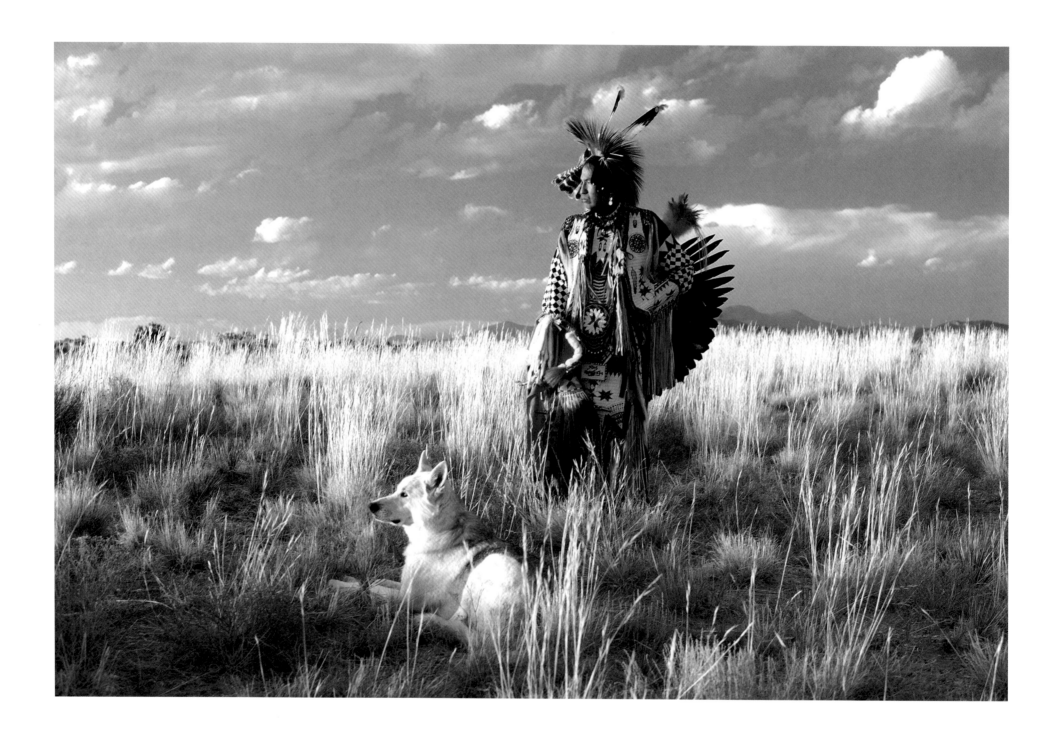

OMAHA INDIAN DANCER ANTHONY PARKER (NUDAHUNGA)
SAN MARCOS, NEW MEXICO, 2005

A Lakota woman named Elaine Jahner once wrote that what lies at the heart of the religion of hunting peoples is the notion that a spiritual landscape exists within the physical landscape. To put it another way, occasionally one sees something fleeting in the land, a moment when line, color, and movement intensify and something sacred is revealed, leading one to believe that there is another realm of reality corresponding to the physical one but different.

—Barry Lopez, *Arctic Dreams*

CRAIG VARJABEDIAN

THIS PHOTOGRAPH HAS A QUALITY OF THE PAST BUT IS A MOMENT OF the present. It is unexpected and makes the viewer ask, When was this photograph taken? I made it during a New Mexico Photography Field School workshop in 2005 that I was teaching that focused on outdoor portraiture.

I said earlier that a photographic portrait should reveal an essence of the subject. It should demonstrate his or her authenticity—not as a person posing, not just as a paid model. It should reflect a real sense of who the subject is inside. That's one reason I appreciated being able to make this photograph, because it revealed something important and essential about Anthony Parker, the subject.

Anthony Parker is a performer—a professional actor and a champion

powwow dancer. He is also a father, a printer, a friend. He has so many interests that it's hard to keep track of them. He's also in and out of New Mexico because of his movie career (his most recent role was in *Comanche Moon*), so my students and I were blessed to have this opportunity to work with him and to learn the importance of tradition, history, and culture to him. He's not just a man dressed in Native American regalia. Anthony created much of his own outfit and can teach the meaning and symbolism behind it. He knows the history of his culture and has every intention of keeping that culture alive.

Anthony says he is a performer, but this image is not of a performance. This was a natural moment of his reality and of Buck's, the dog. Everything in this image is connected; there is a strong relationship between the man and the dog and their environment. The light, the grasses, Buck, and Anthony all belong together, but not because of the camera. They are living outside of time.

This photograph is one of many I made that afternoon, but it is the one in which you see that "moment" when everything fell into place. If you were to line up all the photographs I made of Anthony and Buck, you could follow and recognize the moment unfolding, up to the point where it happens and then fades. I call that the "architecture of the moment."

The climax of those many moments is known as the "decisive moment." Henri Cartier-Bresson elaborated on the phrase in his book *The Mind's Eye: Writing on Photography and Photographers*: "Above all, I craved to seize, in the confines of one single photograph, the whole essence of some situation that was in the process of unrolling itself before my eyes." Ansel Adams commented on this idea, too, in his book *Examples: The Making of Forty Photographs*. He said that "we are concerned not only with a single aspect of the image but with the complexity of the entire experience, a matter of the moment but also involving the realities of light, environment, and the fluid progress of perception from first glance to release of the shutter."

The concept of a decisive moment and the complexity of the entire experience figures in many of my pictures. I can see or sense that moment coming. The formal aspects of light and environment fall into place, and I experience a precognitive sense of the picture coming together. When I see it happening, it is as if cosmic tumblers are falling into place and I recognize a powerful moment. That recognition makes me release the shutter. If I even take the time to say, "Oh, look at this!" I will have missed it. For example, when I made the next photograph in this book, "Sparrow and her Cowboy Richard," (page 104), there was a moment when Sparrow reached the culmination of her bow and looked directly at me. That was the decisive moment. I was fully aware of it and was able to make an exposure.

Knowing the decisive moment is intuition and gift. Good photographers must be able to transcend the tool of the camera and simply receive what is given to them. They must have technological practice and experience, but unless the decisive moment is recognized and the photographer is ready, many inspired photographs will be lost.

It's interesting to me that Cartier-Bresson didn't print his own work. As a photojournalist, once he took the photograph, he was finished, and someone else developed it. He had made the image and moved on. Ansel Adams, on the other hand, photographed, developed, and printed his own images. He tried to evoke what it was like to stand in a "particular place at a particular time" by the way he processed and developed the negative and the print. Adams had a wonderful analogy from the world of music. He felt that the negative was the musical score, containing all the notes, and the print was the performance, through which he could share his experience of having been there.

When I produce a print, either digitally or in the wet darkroom, I, too, want to share a sense of what it was like when I made the photograph. I must look at the "performance" in the darkroom or on the computer screen to see whether it harmonizes with what I felt and want to share. For example, when I made this photograph, the light was

palpable. I felt I could touch it. It existed together with Anthony, Buck, and that endless horizon.

But back at the studio, when I looked at the raw digital file, I found that the camera had not recorded the palpable quality of the light that day. The image was only of the man, the dog, and the landscape. I had wanted to express in my photograph the completeness of that moment when man and dog were paired with land and light. So to make that light evident in the photograph, I enhanced the sky with a nik Color Efex yellow-orange digital photographic filter. I wasn't trying to change the image, add or take things out, or create a mood that wasn't appropriate. I wanted to share what I felt.

In my work, any image manipulation must be invisible. If the viewer can tell that I did something to an image—if I make it obvious—then I have gone too far, and the image will be unsuccessful. If I had made the sky in this photograph purple, for example, it would have been too obvious and thus distracting. I'm not against manipulating images. I think some of the work I've seen in which reality has been changed, such as computer-generated images in movies, is just amazing. But in my work, an image needs to be congruent with human vision. A viewer should believe in the reality of my photographs.

The resulting image in this picture reveals the light I experienced that evening, which completes the photograph. The moment Anthony and Buck looked off into the distance was that perfect moment when light, environment, and perception connected—a reality too beautiful for words but revealed in the photograph.

ANTHONY PARKER

I was raised in Nebraska, along the Missouri River, about seventy-five miles north of Omaha—close to where Minnesota and Nebraska and South Dakota meet. I grew up with lots of trees, lots of water. Nowadays

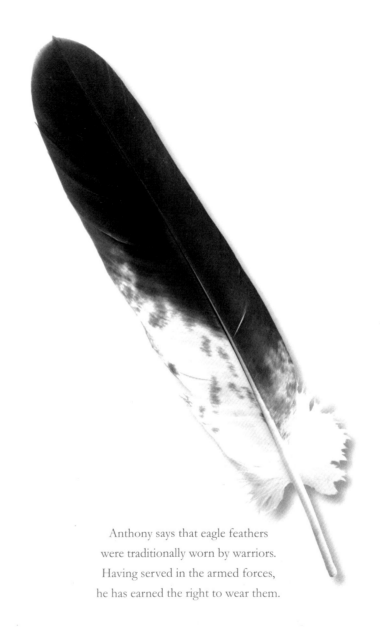

Anthony says that eagle feathers were traditionally worn by warriors. Having served in the armed forces, he has earned the right to wear them.

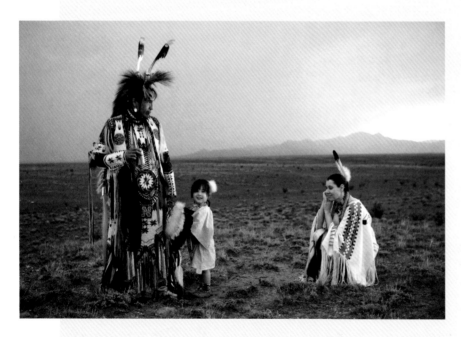

A year later, I made this photograph of
Anthony and his wife Nancy with their daughter Tashina.

I live in Albuquerque. I've been dancing in the powwow circuit most of
my life. My grandpa was taking me to powwows when I was little. I would
sit on his lap and fall asleep—he was playing on the drum. Dancing is part
of my family tradition. I can trace it down a long line of men in my fam-
ily, to my great-grandfather and his dad. That's what tradition means to
me—going back through generations.

I'm part of a dance troupe, the Red Wing Dance Company. But a
lot of time I'll go to powwows independently. My category—kind of
like rodeo or a basketball tournament—is "traditional dancer, male." I'll
typically do a dance a warrior does when he is preparing to go to war or
has come back from war. The movements I do tell a story—of what I've
done, what I saw, what I brought back. The ribbons on my outfit are sym-
bolic of scalp locks. Everything you see here is symbolic or has a reason
behind it.

I have the right to wear eagle feathers. Eagle feathers were awarded
to a warrior for every coup taken, every scalp taken, everything a warrior
may have done for the people. A warrior back in those times would have
been someone of great status, great power. Nowadays you might see small
children at these powwows with eagle feathers. A lot of people will have
them, but there was a time when not just anyone could have one. My name
Nudahunga means, "I am a chief," and having served in the armed forces
myself, I have the right to wear these feathers. I firmly believe I was born
to keep tradition alive.

There was a time when no one could wear his or her traditional clothes.
In the 1800s, the United States government took everything away, all the
regalia. All the feathers and decorations held medicine. When the military
saw the regalia and the feathers, they knew it meant war. So they took
all the regalia away. The checkerboard material of my outfit is based on
what the Natives did after that. The Natives would play cards to pass the
time—they gambled. The design of the checkerboard is based on the dia-
mond playing card. Sometimes you'll see hearts, diamonds—people might

wonder, Why would anyone put that on an outfit? Well, that's where it comes from.

The shield that I'm carrying on my right forearm I made. It's round, but when you get it wet it'll start to bend. The ermine hides hanging from it are symbolic of what chiefs wear, from sides of war bonnets. There is a red drape cloth hanging on there. I'm from the Omaha tribe; my clan is the Bird clan. The design is a magpie to symbolize my clan.

July fourth, the day of the shoot with Craig, we were out on a private ranch, about ten miles south of Santa Fe. I was part of a workshop that Craig was conducting that day. It was pretty warm, standing out there in leather. We shot for about three hours, until dusk, when the shadows were coming. I was wearing my dance outfit for the traditional dance—a war dance.

I began by just standing for the students to photograph. I asked Craig what to do and he replied, "Just move around naturally." So I started to dance. And then, because it was so hot, I'd stop for a bit. That's when Craig took this photograph. I had a knife sheath—you can't really see it—I put my hand on the knife sheath and looked to my right and he took the picture.

I think Craig liked that moment, because the weeds and grass captured the sunlight, and it looks like it's on fire. I like the photograph because I'm looking into the sun, me and the dog both are. It doesn't look like I'm trying too hard, doesn't look like Buck is trying too hard. It's peaceful and serene, like waiting for the powwow grand entry.

When teaching the human or the horse one must try to sense exactly where they are in any given moment.

—John Saint Ryan, horse trainer

CRAIG VARJABEDIAN

THIS PHOTOGRAPH WAS MADE DIGITALLY, AND ORIGINAL fine prints of the image are made in color. I'll talk about the photograph, but first I want to look briefly at the debate over cameras.

I have long appreciated digital cameras. I have been working with them for the last several years. The instant feedback is tremendously helpful and exciting. I can see immediately the results of something I have photographed.

But this begs the question, Do I prefer a digital camera to a film camera? No, not really. The digital camera is just another tool with which to make an image. It is remarkable to me how much is being said and written debating the virtues and shortcomings of digital versus traditional photography. I believe these debates miss the point: there really is no *better*, there is only *different*. The measurements that define almost anything are always those of something that came before. In the beginning, painting defined the first daguerreotypes, then platinum prints defined silver gelatin prints, and so forth. In the end, the beautiful delicacy of a black-and-white gelatin silver print and the elegance of a black-and-white pigment print can be equally affective on a viewer. Although a photographer or a collector might prefer one medium over another, each must be considered for the intrinsic qualities it can contribute to the image.

Just as I claim that digital cameras hold no sway for me over film cameras, neither is black-and-white or color film more valuable than the other. They are simply called for in different situations. It is up to the photographer to make the appropriate decision about what will best render the intended subject.

I have done much of my work in black and white, mainly because I think black and white is transformational. I feel that I have more flexibility in ways of rendering light in black and white than I do in color. It's hard to accept color as transformational because it is too close to reality and thus can be overwhelming. Color tends to make us concentrate on the surfaces of things, whereas black and white leads us to examine edges and structures, to become more intimate with an image. Black

and white tends to evoke a quality of light in an image that is much subtler than can be rendered by color.

People look at black and white and color in different ways, but color does have its place. Sometimes I think color is trivialized, so that we glance past color photographs. After all, most of us see in color, whereas a black-and-white photograph is, for most viewers, a change in reality— we don't see in black and white, so we have to look at it differently. We are drawn to examine it perhaps more deeply.

That said, I'll repeat: This photograph was made digitally. Fine art prints of it are in color. In this book, it is reproduced in black and white.

I've written about recognizing a moment in which everything falls into place and about being able to make a picture of that moment.

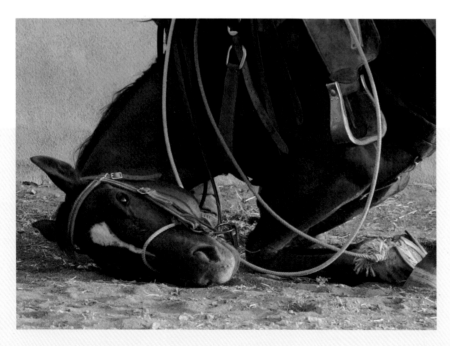

I see my photograph *Sparrow and Her Cowboy Richard*
as really a portrait of a horse.

Sometimes I can anticipate that something is about to happen and have my camera ready and waiting. The afternoon I made this photograph, during a New Mexico Photography Field School workshop, we were at Clint Mortenson's ranch at San Marcos. I had no expectations about what might happen. I didn't know the model, Richard, or his horse, Sparrow—didn't know what they were capable of. We were standing by an adobe wall and all I knew was that using the wall as a backdrop would probably be a good idea. Once Richard and Sparrow had moved in front of it, Richard said, "Do you want to see my horse do some tricks?" and I said, "Sure." They did the first trick, Sparrow bowing.

Then Richard had her do it again. At the moment Richard looked away from me and the students, Sparrow looked at me, and the moment changed. And right then, with my digital camera, I made a picture of that change. I made a picture of a horse and a cowboy, not a picture of a cowboy and a horse.

This was the first digital photograph I ever made that I felt was as strong as the images I'd been making in black and white with my view camera. The moment I released the shutter I knew I had made a wonderful image. The picture is tied together by the afternoon's diffused light and the wonderful adobe wall behind the pair. Richard's white shirt is luminescent, contrasting with Sparrow's dark curves and shadows. He is looking at Sparrow, making sure she is all right and ready to stand again in a moment. What I see is Sparrow's trust of Richard, his care for and attention to her, and their openness in sharing this all with me. It's a triangle. This picture transcends a portrait of a cowboy and horse; it presents a moment of trust and affection. Some people say horses don't feel affection for their owners, but I disagree. I see love, respect, familiarity, trust—all these emotions mutually between a horse and a man.

The reality presented in a photograph is sometimes different from the reality of the subjects themselves. My desire is not to make a record of something; it is to share an emotional response to what I have seen. In

talking with Richard later, I found that he was slightly bemused by my impressions of this image.

Do I feel there's a relationship between people and horses? Well, maybe. I think it's different for everybody. I don't think it's an emotional relationship for a lot of people. Dogs and owners are emotional, but horses are not dogs. They respond differently. You can have a horse for a certain amount of time—you'll get more attached to it. Horses might become attached to what might become a pleasurable experience for them, like a treat, eating, or coming up to be scratched. But they're not like a dog. Horses would rather be with other horses, while a dog would rather be with you. They may get to a point where they might chose to be with you, but in their heart of hearts, I believe horses would rather be out running around with their buddies.

I guess I do establish a relationship, but it's not an emotional one. I've had so many horses come and go: I've never had a horse I've wanted to keep forever. I've had Sparrow for a while, because I owned her mom. Her mom was the most athletic horse I ever had. She was like riding a cat. She was a thoroughbred. I loved what I was able to do on her. However, she was the biggest pain in the butt, so I did eventually sell her. She wasn't a friend. But I loved the experience I had on her. I think about selling Sparrow sometime—she's often a pain—but I can get a lot of things done with her.

When you work with a horse, you first have to get them started (it used to be called "breaking" them, but not any more), and you've got to be slow and gentle. You've got to understand the psychology of horses. You have to get around their fears. It works best if you're not forcing your will on them and you're working with them. Horses have to accept what is happening to them, and the trainer has to know what he or she is doing. As the trainer, you have to have the final word.

To teach a horse a trick means repetition. If a horse stops, you have to make him keep on. If a horse knows a trick and won't do it, you can't let him get away with it. When I'm training, I'm conscious of getting as much from a horse as I need to ask. And I'm conscious about everything going on. You've got to be careful where you work. If the ground isn't soft, if it's hard and rocky, a horse won't be comfortable on her knees. You start by teaching a horse how to bow, one leg down and the other one out.

I'm a horse trainer. But I do consider myself a cowboy—not the same, though, as someone who works every day on a ranch. There are very few real cowboys anymore. There are just a handful of them left. I have a friend who runs a ranch—he's seventy-two but he's still out there working it every day. He's a good horseman. Cowboys are people who learned their trade from mentors, from cowboys who knew what they were doing. I learned that way—my great-uncles were horse trainers, and I learned at a fairly young age. But they were also cow people, so I learned my cowboy skills from them, too. I've learned from lots of folks. I go to Ray Hunt's clinics. I like working with Randy Rima here in New Mexico. He's a great horseman, maybe starts colts better than anyone. Of course, he'll say the same thing about anyone else.

There are cowboys who'll identify themselves only that way—they live it, breathe it every day, that's their life. I've lived that way. At a certain point of my life, it was all day, every day. But I'm not doing that now. I'm into different things—I'm a renaissance man. I've done construction. I used to be an outfitter, and I guided for other outfitters in New Mexico and Colorado. I went to art school in California. I hunt. I fish. Now I paint and I make jewelry.

But I still do cattle work. I help out with branding, castrating, and vaccination. I've been around the cowboy life all my life. I live on a ranch. I'm a horse trainer. I have the skills so I can help with cattle. I rodeo. I like the high country. The spirit of cowboying—that's what I want to have every day, even if I'm not cowboying.

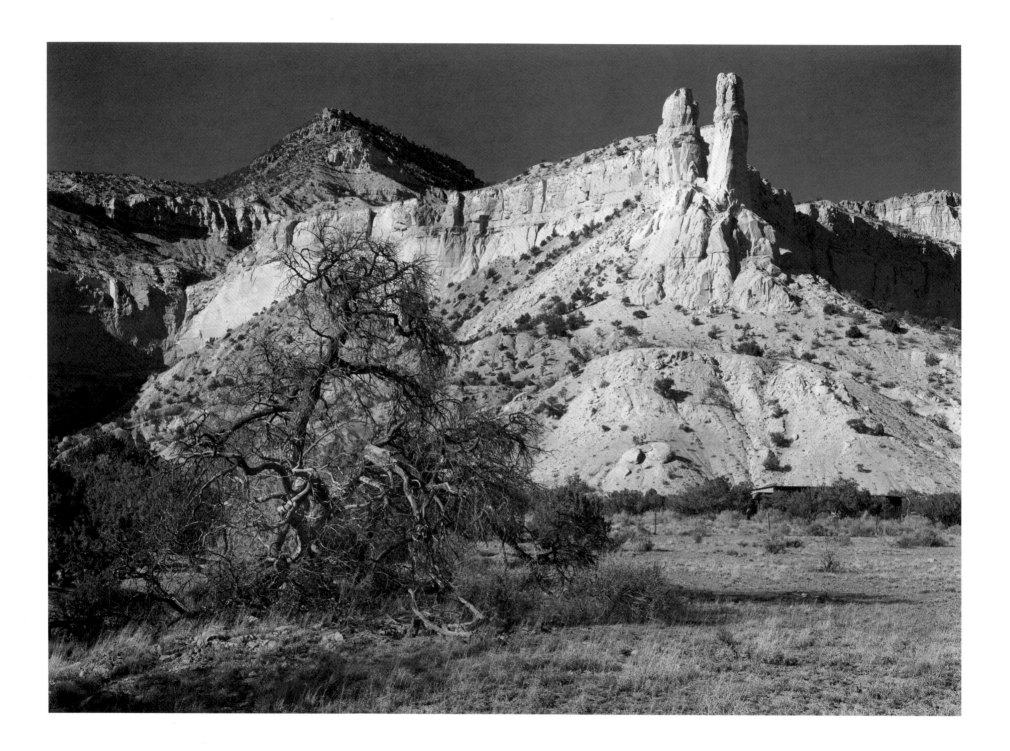

AFTERWORD: *Lux Sola Gratia*
A Photographic Meditation

It is my opinion that art lost its basic creative drive the moment it was separated from worship.

—Ingmar Bergman

JAY PACKER

THE LATE AFTERNOON SUN HANGS LOW IN THE WESTERN SKY OVER Ghost Ranch, nestled in the high desert of northern New Mexico. An intermittent warm breeze stirs in the sparse grass and sagebrush, while sandstone buttes at the eastern edge of the wide basin shine golden beneath a few wispy cirrus clouds. In the lengthening shadows, Craig Varjabedian patiently readjusts the position of his tripod for the sixth or seventh time, exchanges the cells of his Protar lens set, and considers the resulting image on the ground glass of his 5×7 view camera. For my benefit, he is carefully arranging a skeletal oak tree, a dry arroyo, and the distant cliffs into the makings of a photograph.

Over the last few years, I've spent a lot of time carefully studying Craig Varjabedian's photographs; his images have become a source of considerable fascination and inspiration for me. I've come to Ghost Ranch to follow him around in his natural habitat, ask lots of annoying questions, and see what I can learn about how he works.

Under the enormous dome of the New Mexico sky, Craig and I have spent the day wandering between juniper and sandstone, around *piñon* and *cholla*, along *acequias* and cottonwoods. While absorbing the hard-edged light of the high desert, we've been absorbed in an animated, unscripted exchange about a wide range of photographic topics. We've discussed equipment, compared techniques, and evaluated philosophies. We've admired famous photographers and analyzed their photographs. We've scouted promising vistas and prowled secluded canyons, and even managed to point the business ends of our cameras at the grand landscape a few times.

Throughout the day I peppered Craig with as many technical queries as I could, questions about films, developers, cameras, lenses, filters, tripods, and darkroom techniques. Photographers love to talk shop; although we know better, we all hope that some as yet unfamiliar and exotic piece of photographic gear or esoteric technique will miraculously transform our images from mundane to spectacular. Craig patiently answered all my questions, thoughtfully and completely. But the questions I most wanted to ask remained unspoken. I didn't ask which film developer would imbue my highlights with meaning and my shadows with significance. I didn't ask what film and filter combination would render both the New Mexico sky and the autumnal cottonwood leaves the precise shades of gray that evoke the eternal in the transitory. I didn't inquire which lens design could best portray wonder, or what focal length most effectively captures the mystery of faith. Although Craig has actually done all these things (as the pictures herein demonstrate), such questions would miss the point, rather like asking E. B. White which brand of typewriter can best describe the hope of spring contained in a January mail-order seed catalog.

There are two fundamental choices that a photographer must make: *what* to include in a prospective image, and *when* to release the shutter. Used skillfully, the camera can capture an evocative, decisive slice of space (what) and time (when) in the form of a photograph, frozen permanently for more contemplative examination. The essence of a photograph is determined not by the lens, film, or format, but by the eye behind the camera. In photography as in life, we do not see things as *they* are, we see things as *we* are. The beauty, meaning, and mystery in Craig's photographs reflect who he is and how he perceives the landscape and people of northern New Mexico; that his photographs effectively convey this compelling vision to the rest of us is a measure of his considerable photographic skill.

Craig Varjabedian has a solid grasp of photography's technical side; he studied with Professor Phil Davis at the University of Michigan and has a Masters degree in photography from Rochester Institute of Technology. After completing his formal education, his creative vision was honed while studying with both Ansel Adams and Paul Caponigro. He has worked diligently to perfect his craft for over thirty years.

But technical competence, photographic vision, and perseverance alone do not fully account for his remarkable photographs, two of which adorn the walls of my living room: *Cottonwood Trees No. 5, La Cienega, NM,* and *Sunset and Evening Storm, Cañoncito at Apache Canyon.* They share at least one unifying thread: they both depict "ordinary" parts of the New Mexico landscape at extraordinary moments. New Mexico has hundreds of little towns and villages, most with small Catholic chapels, and literally millions of cottonwood trees. But in these images, the town and the cottonwoods become archetypal, representative of their many kindred, frozen on film in the moment of their transformation by the blessing of the evening light.

The mechanics of accomplishing this photographic alchemy are daunting. Most aspiring photographers assume that if only they could be present at moments such as these, they, too, could make wonderful images. But consider: when photographing with a 5 × 7 view camera, a practiced and fluid photographer will take at least ten minutes to set up the camera and tripod, select a lens of appropriate focal length, frame and

focus the image, determine the correct exposure, and expose the film. When the light is just right, ten minutes is an eternity; below the Arctic Circle, beautiful light almost *never* lasts ten consecutive minutes. (In my experience, nothing will extinguish the exquisite light of "magic hour" more expediently than setting up a view camera.) Thus, Craig has to correctly *anticipate* the possibility of extraordinary light and its potential interaction with the landscape, rather than respond to it after the fact. And as Chief Dan George aptly observes in the film *Little Big Man*, "Sometimes the magic works, and sometimes it doesn't."

Driving to Ghost Ranch from Santa Fe this morning, Craig and I passed through the inconspicuous hamlet of Hernandez; as always, I glanced through the trees to the east, looking for the familiar silhouette of the chapel and the distant Sangre de Cristo range immortalized sixty years before by Ansel Adams in his most celebrated image. In the legendary tale of *Moonrise, Hernandez, New Mexico*, Adams recounts frantically stopping his station wagon and racing to set up his 8×10 camera before the light disappeared from the scene. A missing meter necessitated an exposure calculation based on the known luminance of the full moon; the shutter was released at the last possible second, and the rest is history. The making of the image required acute perception, mechanical prowess, and technical expertise, but that autumn evening in 1941 was truly extraordinary; as thousands of photographers who have made the pilgrimage to Hernandez can attest, it doesn't look like *that* very often. Even Ansel Adams graciously allowed as how, "Sometimes I do get to places just when God's ready to have somebody click the shutter."

In this regard, Ansel was not unique. Craig has written eloquently of his experiences during the Morada Photographic Survey, the project that resulted in his book *En Divina Luz*. He describes the light in and around an unnamed morada on one particularly memorable winter evening as "otherworldly." In the sentinel, transfiguring illumination, Craig discovered his vocational quest and recounts his response to it, "If it was my destiny to receive such *gifts* (italics mine) while making photographs, I concluded it would be through the lens of my camera that an answer might reveal itself."

There is a distinctly uncommon sense of reverence that permeates many Varjabedian photographs. In *Four Screenplays of Ingmar Bergman*, the Swedish filmmaker wrote, "It is my opinion that art lost its basic creative drive the moment it was separated from worship." The creative drive to which Bergman refers is alive and thriving in Craig's work, from which one might correctly infer that he is a man of humility. His images do not call attention to the photographer; rather, they are windows, conduits that describe an extraordinary interplay between heaven and earth, between light and shadow, between blessing and blessed.

Preternatural anticipation, *Divina Luz*, reverential wonder; none of these topics are even briefly mentioned in my copy of *The Encyclopedia of Photography*, nor can I find them among the courses listed in photography school catalogs. How do I account for this *magnum mysterium*, this unspoken extra dimension, this grace that allows a photograph to represent much more than the subject it depicts? Does this quality come *from* the photographer, or *through* him? Is it the expression of a creative vision, or a gift? Can it be acquired through industry, or only gratefully received? Characteristically, Craig's words suggest unmerited favor; he describes many of his images as "moments of grace." I'm less sure than he about the unmerited part . . .

There is a Celtic belief that heaven and earth are only three feet apart, but in certain "thin places" the gap is even smaller. A "thin place" is a site where the veil that separates this world from the next is partly lifted, and the Light is not entirely confined to the other side. It seems to me that Craig Varjabedian has been blessed with an uncanny knack for finding the evanescent "thin places" of northern New Mexico. As the ephemeral pleats in the fabric between heaven and earth periodically part, blessing the land and people with the grace of numinous Light, he waits patiently

with his camera. In the best of his photographs, the veil becomes as sheer and translucent as a sheet of his Tri-X film. With grandeur and subtlety, dramatically and quietly, his photographs bear witness to that Light. It emanates from the cottonwoods of La Cienega, the shining bush above the chapel in Cañoncito, snow clinging to the cathedral of St. Francis, adobe walls of moradas *sin nombre*, and clouds suspended between the earth and sky above Cerro Pedernal.

The sun sinks lower, and the cliffs glow orange with the benediction of sunset. In the distance, the growl of an engine disrupts the silence and soon grows louder; a turquoise 1955 Chevy pickup truck rumbles down the dirt road thirty yards from the tripod and coasts to a stop. Rob Craig, executive director of Ghost Ranch, climbs out of the cab and ambles over to the camera position. He has stopped to talk to Craig, to elaborate on some subtle nuances of Ghost Ranch history that may have some bearing on Varjabedian's ongoing photographic project at the ranch. The photographer listens intently, occasionally asking questions to clarify a fine point and periodically glancing over his shoulder toward the camera and the scene unfolding before it. As the conversation and the waning light approach their respective but simultaneous crescendos, Craig politely excuses himself for a moment, takes a quick light meter reading, and swiftly exposes four sheets of film in less time than it takes to write about it. The light fades silently from the hills, and the two men finish their discussion in the gathering twilight.

Craig and I shake hands and part company in the Ghost Ranch parking lot; the taillights of his truck fade from view as he turns south toward his studio in Santa Fe. As I drive north toward Colorado in the twinkling New Mexico night, I reflect on the events of the day. I am quietly content, and grateful: for the day, for the light, for my brief sojourn through this enchanted landscape, for Craig and his work. The name *Varjabedian* means "great teacher" in Armenian; maybe Craig showed me the answers to some of the questions I never asked.

Jay Packer and **Craig Varjabedian** share an interest in large format photography. They met because Jay bought the "widowmaker," a tripod mentioned in the Cañoncito story. He found Craig's business card taped to it, and recognized the name as the photographer of pictures he had seen and admired. While visiting Santa Fe, he dropped by Craig's studio and they have been friends ever since. Dr. Packer photographs landscapes, focusing on the Western scene, when he is not at his medical practice in California.

1957 Born September 26 in Windsor, Ontario, Canada, to Hazel and Suren Varjabedian.

1970 Family moves from Canada to United States. Purchases first "serious" camera, a TLR Yashica MAT 124G at Kmart.

1972 Meets Ansel Adams at a gallery in Birmingham, Michigan; becomes committed to becoming a fine-art photographer after seeing Adams's original photographs and gaining a direct understanding of his total dedication to creative photography.

1979 Completes bachelor's degree in photography at University of Michigan, studying with photographers Phil Davis and David Reider and Gestalt psychologist Rudolf Arnheim. Attends workshop in Carmel, California, with Ansel Adams. Visits New Mexico. Opens a creative design and photography studio. Marries Kathryn Ruth Strickland.

1981 Opens Duffy Gallery, a fine-art photography gallery in Ann Arbor, Michigan.

1982 Makes the photograph *Illuminated Stream, Dawn, Plymouth, Vermont*, which he considers to be his first photograph that fully conveys what he saw and felt at the moment of exposure.

1984 Attends Rochester Institute of Technology for master of fine arts degree. Studies with Richard Zakia and semiotician Mihai Nadin. Meets photographer Paul Caponigro, who is presenting his important exhibition *The Wise Silence* at George Eastman House.

1985 Moves to Santa Fe to complete master's thesis, and stays.

1986 Founds the New Mexico Photography Field School, offering intense, short-term, creative photography learning experiences.

1988 Meets Cindy Lane working at local copy shop and begins long-time business partnership and friendship.

1989 Begins the Morada Photographic Survey which receives numerous grants and awards—from the National Endowment for the Arts, the Samuel H. Kress Foundation, the McCune Charitable Foundation, the New Mexico Endowment for the Humanities, and others.

1990 Co-produces the Emmy-winning PBS documentary film *En Divina Luz* with KNME-TV of Albuquerque. Meets eminent photography historian Beaumont Newhall, who offers support for the Morada Photographic Survey.

1991 Reconnects with Paul Caponigro in Santa Fe and works with him as dark-room assistant to help produce prints for Caponigro's *Masterworks from Forty Years*. First one-man exhibition held at the Knight-Gomez Gallery in Baltimore. Prints are acquired by the Baltimore Museum of Art. Takes his best-known photograph, *Moonrise over Penitente Morada, Dusk, Late Autumn, New Mexico*.

1994 Publishes the book *En Divina Luz: The Penitente Moradas of New Mexico* with the University of New Mexico Press. The national exhibition opens at the Albuquerque Museum and travels to nineteen venues. Publishes limited edition *Portfolio I: The Moradas of the Penitente Brotherhood*, containing eight original photographs. Meets Paul Cousins at Ghost Ranch workshop.

1995 Receives grant from the Peter and Madeleine Martin Foundation for the Creative Arts for *By the Grace of Light: Images of Faith from Catholic New Mexico*, a project celebrating the four-hundredth anniversary of the arrival of Catholic faith in New Mexico.

1996 Daughter Rebekkah Suren born. Establishes the Morada Archive at the DeGolyer Library, Southern Methodist University, where negatives, prints, and field notes are preserved.

1998 Publishes the book and presents the exhibition *By the Grace of Light: Images of Faith from Catholic New Mexico* with the Colorado Springs Fine Arts Center. Exhibition travels to five venues. Publishes a limited-edition, privately published book, *As the Spirit Stands Still*.

1999–2001 Photographs are featured in *New Mexico Magazine* and *The Santa Fean Magazine*. Contributes articles and photographs to *Petersen's Photographic Magazine*. Photographs outside of New Mexico, traveling to the Grand Tetons, Glacier National Park, Big Sur, Yosemite, and Monument Valley with Paul Cousins. Exhibits at several venues in New Mexico, Texas, and Rhode Island. Expands offerings and teaches photography workshops at the New Mexico Photography Field School.

2002 Begins photographing Ghost Ranch, a twenty-two-thousand-acre ranch in northern New Mexico known for its association with Georgia O'Keeffe. A book is planned with author Robin Jones to be published by the University of New Mexico Press.

2003 Assembles stories for *Four & Twenty Photographs: Stories from Behind the Lens* with author Robin Jones. Begins exhibiting at the Gerald Peters Gallery in Santa Fe. Large collection of photographs is acquired by Los Alamos National Bank/Trinity Capital Corporation. Continues making photographs at Ghost Ranch.

2006 Builds new studio and headquarters for the New Mexico Photography Field School with photographer William Plunkett and Cindy Lane. Publishes limited edition *Portfolio II: New Mexico*, containing eight original photographs.

LIST OF ILLUSTRATIONS

Abbey, Edward. *Desert Solitaire: A Season in the Wilderness*. New York: Ballantine Books, 1968, p.155.

Adams, Ansel. *Examples: The Making of 40 Photographs*. Boston: Little, Brown and Company, 1983, p.156.

Cartier-Bresson, Henri. *The Mind's Eye: Writing on Photography and Photographers*. New York: Aperture, 1999, p. 79.

Cather, Willa. *Death Comes for the Archbishop*. New York: Random House, 1971.

Chronic, Halka. *Roadside Geology of New Mexico*. Missoula, MT: Mountain Press Publishing Co., 1987.

Colbert, Edwin H. *The Little Dinosaurs of Ghost Ranch*. New York: Columbia University Press, 1995.

Collier, John Jr. "Interview, conducted by Richard K. Doud," January 18, 1965. Smithsonian Archives of American Art. http://www.aaa.si.edu/oralhist/collier65.htm. (accessed November 12, 2005)

Cruz, Victor Hernandez. "Lowrider" poem in *Under the Fifth Sun: Latino Literature from California*. Ed. Rick Heide. Santa Clara, CA: Santa Clara University; Berkeley, CA: Heyday Books, 2002.

DeBuys, William. "One hundred Years of Change in the Bosque of the Middle Rio Grande." A presentation to the Middle Rio Grande Bosque Consortium's Fall Conference, November 5, 1999. http://www.fws.gov/bhg/Literature/BillDebuys.htm (accessed March 14, 2006)

Einstein, Albert, "The World as I See It," essay in *The World as I See It*. Abridged ed. New York: Philosophical Library, 1949, pp. 1–5.

Eldredge, Charles C. *Georgia O'Keeffe*. New York: Harry N. Abrams, 1991, p. 21.

Horgan, Paul. *Lamy of Santa Fe*. New York: Farrar, Straus and Giroux, 1975, pp. 415–16.

Lopez, Barry. *Arctic Dreams*. New York: Charles Scribner's Sons, 1986, p. 273.

Lynes, Barbara Buhler and Ann Paden, eds. *Maria Chabot—Georgia O'Keeffe: Correspondence, 1941–1949*. Albuquerque: University of New Mexico Press; Santa Fe: Georgia O'Keeffe Museum, 2003.

Mackintosh, Barry. *The National Parks: Shaping the System*. Washington, D.C.: U.S. Department of the Interior, 1985.

Poling-Kempes, Lesley. *Valley of Shining Stone: The Story of Abiquiu*. Tucson: University of Arizona Press, 1997.

Ryan, John Saint. Personal website, http://www.johnsaintryan.com/training.htm (accessed November 17, 2006)

Saint-Exupery, Antoine. *The Little Prince*. New York: Harcourt, Brace, and Company, 1943, p. 73.

Sheehan, Michael J., "Introduction," in *By the Grace of Light: Images of Faith from Catholic New Mexico*. Colorado Springs, CO: Colorado Springs Fine Arts Center, 1998, p. 6.

Varjabedian, Craig. *By the Grace of Light: Images of Faith from Catholic New Mexico*. Colorado Springs, CO: Colorado Springs Fine Arts Center, 1998.

———. *En Divina Luz: The Penitente Moradas of New Mexico*. Albuquerque: University of New Mexico Press, 1994.

Weber, David. *On the Edge of Empire: The Taos Hacienda of los Martinez*. Santa Fe: Museum of New Mexico Press, 1996.

Wood, Myron. *O'Keeffe at Abiquiu* (text by Christine Taylor Patten). New York: Harry N. Abrams, 1995.

Wright, Barton. *Hopi Kachinas: The Complete Guide to Collecting Kachina Dolls*. Flagstaff, AZ: Northland Publishing, 1977.

FOUR & TWENTY PHOTOGRAPHS

A NOTE ON THE TYPE The text in this book was set in Monotype Garamond. Introduced in 1922, Monotype Garamond is patterned after type found in the archives of the French Imprimerie Nationale, the centuries-old government printing office of France. The Imprimerie type was long believed to be the early work of sixteenth-century typographer Claude Garamond. However, in 1926 type historian Beatrice Ward discovered that the type was actually designed by Jean Jannon, a later designer after Garamond by some eighty years. Jannon's goal was to imitate the great masters of roman type and make their designs available to printers of his day. With its distinct contrast in stroke weights, open counters, and delicate serifs, Monotype Garamond is exceptionally legible and can be set at virtually any size.

PRINTED AND BOUND Everbest Printing Company Ltd.

through Four Colour Imports, Ltd. on 157 gsm Gold East matte paper

DESIGN AND COMPOSITION Melissa Tandysh